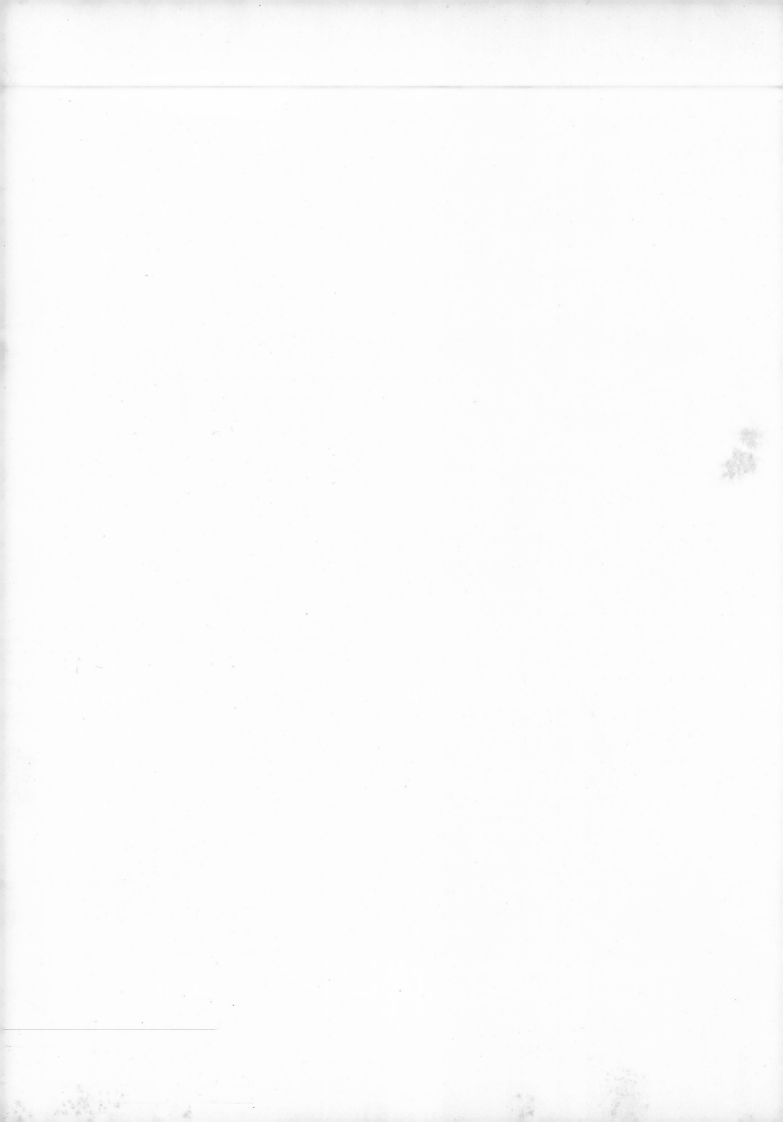

Norman Rockwell

A SIXTY YEAR RETROSPECTIVE

Doctor and Doll. *Original oil painting for* Post *cover, March 9, 1929. Collection John E. Newman*

Norman Rockwell

A Sixty Year Retrospective

———

CATALOGUE OF AN EXHIBITION ORGANIZED BY

Bernard Danenberg Galleries, New York

WITH TEXT BY

Thomas S. Buechner

Harry N. Abrams, Inc., Publishers, New York

SCHEDULE OF THE EXHIBITION

FEBRUARY 11–MARCH 5, 1972	The Fort Lauderdale Museum of the Arts Fort Lauderdale, Florida
MARCH 22–MAY 14, 1972	The Brooklyn Museum Brooklyn, New York
MAY 26–JULY 16, 1972	Corcoran Gallery of Art Washington, D. C.
AUGUST 1–AUGUST 27, 1972	Marion Koogler McNay Art Institute San Antonio, Texas
SEPTEMBER 8–NOVEMBER 5, 1972	M. H. De Young Memorial Museum San Francisco, California
NOVEMBER 12–DECEMBER 10, 1972	Oklahoma Art Center Oklahoma City, Oklahoma
DECEMBER 18–JANUARY 21, 1973	Indianapolis Museum of Art Indianapolis, Indiana
JANUARY 28–FEBRUARY 25, 1973	Joslyn Art Museum Omaha, Nebraska
MARCH 8–APRIL 15, 1973	Seattle Art Museum Seattle, Washington

BOOK DESIGN BY NAI Y. CHANG

Standard Book Number: 8109–2049–2
Library of Congress Catalogue Card Number: 70–38513
Text and reproductions of works of art only
© 1972 BY HARRY N. ABRAMS N.V., THE NETHERLANDS
HARRY N. ABRAMS, INCORPORATED, NEW YORK
Printed and bound in Japan

P R E F A C E

IN 1913, WHEN THE GREAT ARMORY SHOW INTRODUCED MODERN ART to New Yorkers, Norman Rockwell was busy doing one hundred ink drawings for the *Boy Scouts Hike Book*. What part has our most popular artist played in the upheavals which have made us a major power in the art world? Absolutely none. He—and all those other artists with publishers instead of galleries—are the "meanwhile back at the ranch" branch of modern art.

It's time to take another look. In 1968, Bernard Danenberg did an extraordinary thing: he put Norman Rockwell's *Saying Grace* in the window of his gallery on Madison Avenue and hung forty other paintings by Rockwell inside. He had remembered a man whom, as it turns out, nobody wanted to forget; and had remembered him not as an illustrator but as an artist. The exhibition was immensely popular and launched the Rockwell revival—and the Rockwell reappraisal. Subsequently, Harry N. Abrams published the magnificently illustrated *Norman Rockwell: Artist and Illustrator;* Arthur Guptill's 1946 classic, *Norman Rockwell Illustrator* was reissued; the *Saturday Evening Post* came back to life amidst a flurry of Rockwell stories in the national press; and now Mr. Danenberg has organized this exhibition so that we may judge for ourselves. Rockwell in reproduction is not the same as Rockwell in the original. Most people know his work solely through the magazines for which he has done covers, illustrations, and advertisements by the thousands—paper reflections of paintings and drawings nobody ever saw. Now we have the originals before us and can see how they were made, how the artist manipulated brush and pencil, what the colors really are. We can see beyond subject matter to the tech-

nique, and, with perception, to the man himself who created these very surfaces. Is he an artist according to your definition?

He is certainly a phenomenon. To be revived at the height of one's fame is a paradox created as much by our times as by his talents. There are different reasons for different people. For example, some of us have grown used to a new and more rudimentary figurative painting, much of it based on the projection of photographs; his use of this technique is so astonishingly good that he must be regarded as a great master in a medium which has only recently become an acceptable tool for the fine artist. But the essential reason for his current popularity probably lies in the area of his own primary interest, which is neither technique nor aesthetics but the subject itself. Generally speaking, we are fascinated by *what* he has painted rather than by *how*. For many he records the time of our pride with such passionate accuracy and gentle humor that we are overwhelmed with the joys of nostalgia. For others, the young in particular, his visual stories are simply wonderfully entertaining and beautifully told. It is youth's fascination with Rockwell that promises a future as popular as his past.

THOMAS S. BUECHNER
December, 1971

C O N T E N T S

PUBLISHER'S NOTE

In 1943 a fire in Norman Rockwell's studio destroyed many of his original paintings, and over the years many other Rockwell paintings have simply disappeared. In the process of selecting the subjects for the present book it became evident that some of the lost pictures were absolutely essential, in order to have a characteristic variety of the artist's work. We therefore decided to make such reproductions directly from the SATURDAY EVENING POST *covers for which the paintings were originally commissioned (and where they first appeared). It turned out that some of these covers are now extremely rare, and it was largely through Mr. Rockwell's efforts that several of the most important paintings could be illustrated here.*

Norman Rockwell

A SIXTY YEAR RETROSPECTIVE

1910-1929

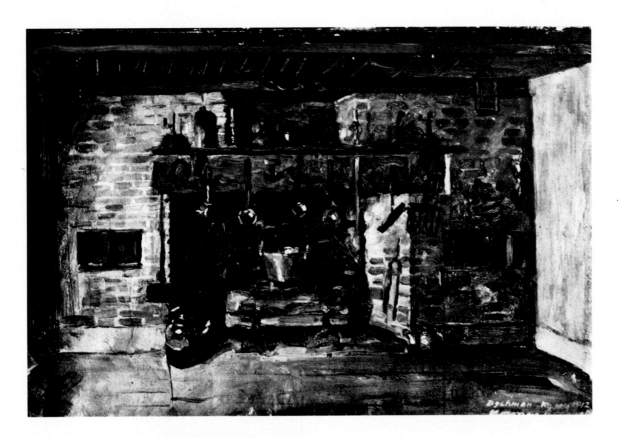

One of the earliest surviving original paintings by Rockwell. 1912. Whereabouts unknown

I N AMERICA, NORMAN ROCKWELL IS THE BEST-KNOWN ARTIST WHO EVER LIVED. His subject is average America. He has painted it with such benevolent affection for so many years that a truly remarkable history of our century has been compiled. Through wars, depression, civil strife, and the exploration of space, Norman Rockwell has drawn subjects from the everyday happenings of which most lives are made. Millions of people have been moved by his picture stories about the awkwardness of youth and the comforts of age, about pride in country, history, and heritage, about reverence, loyalty, and compassion. The virtues that he admires have been very popular, and because he illustrates them using familiar people in familiar settings with wonderful accuracy, he describes the American Dream.

There is an appealing sense of tradition in being a Rockwell watcher, of seeing man land on the moon through the eyes of an artist who recorded Lindbergh's flight across the Atlantic in 1927 and sketched Admiral Dewey's warships steaming into New York harbor in 1899. Another attraction in Rockwell is accuracy. Illustration is a field where a door opening out when it should open in evokes hundreds of letters, and so it is that in this field Rockwell

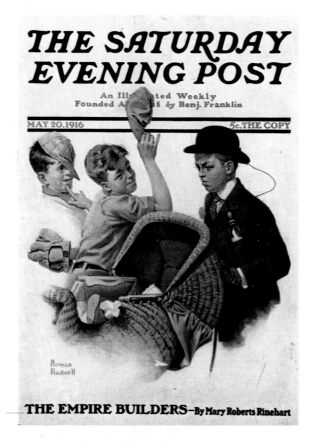

THE EMPIRE BUILDERS—By Mary Roberts Rinehart

Rockwell's first Saturday Evening Post *cover, May 20, 1916*

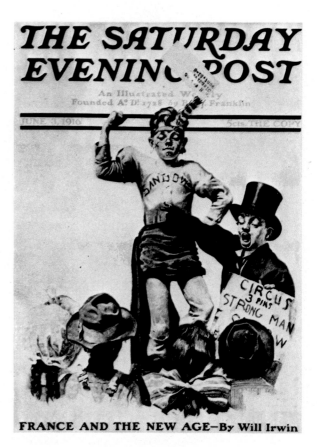

FRANCE AND THE NEW AGE—By Will Irwin

Circus Barker. Post *cover, June 3, 1916. Original oil painting,* Collection *Saturday Evening Post*

has the perfect challenge for his own almost fanatic respect for the visual truth. He is not interested in conveying the idea of a thing, he wants to paint from the thing itself, an actual specific example that he selects with the greatest care.

Here is an account from his autobiography on how to pose a chicken: "You pick up the chicken and rock him back and forth a few times. When you set him down he will stand just as you've placed him for four or five minutes. Of course you have to run behind the easel pretty quickly to do much painting before the chicken moves. But it's better than trying to paint him while he's dashing about the studio. If you want to paint the chicken full face the procedure is even more complicated because the eyes of a chicken are on the sides of his head and when he looks at you he turns his head. I puzzled about that for quite a while. Finally I got a long stick and after I'd set the chicken down and gone behind my easel I'd rap the wall at one side of the chicken and he'd turn his head toward me to look at the wall. It's very strenuous painting a chicken. . . ."

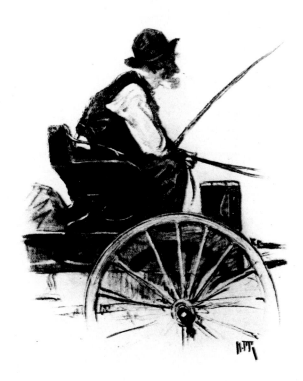

Illustration from
Boys' Life, *1915*

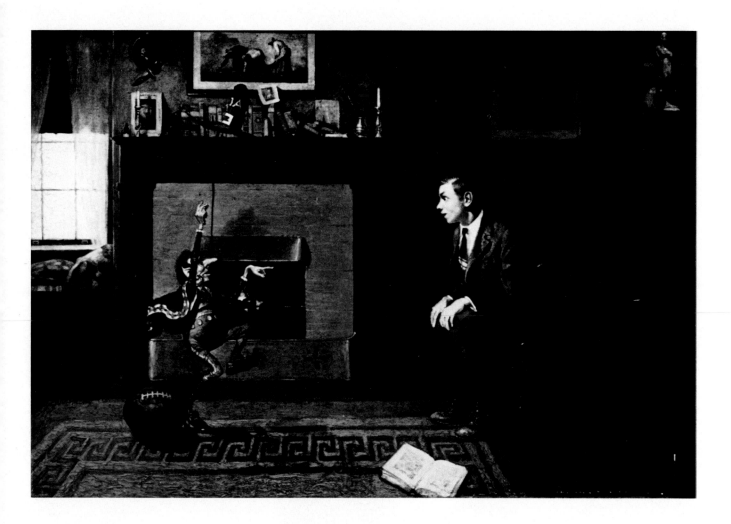

*Illustration for "*The Magic Football*" by R. H. Barbour,* St. Nicholas, *December, 1914. Collection Norman Rockwell*

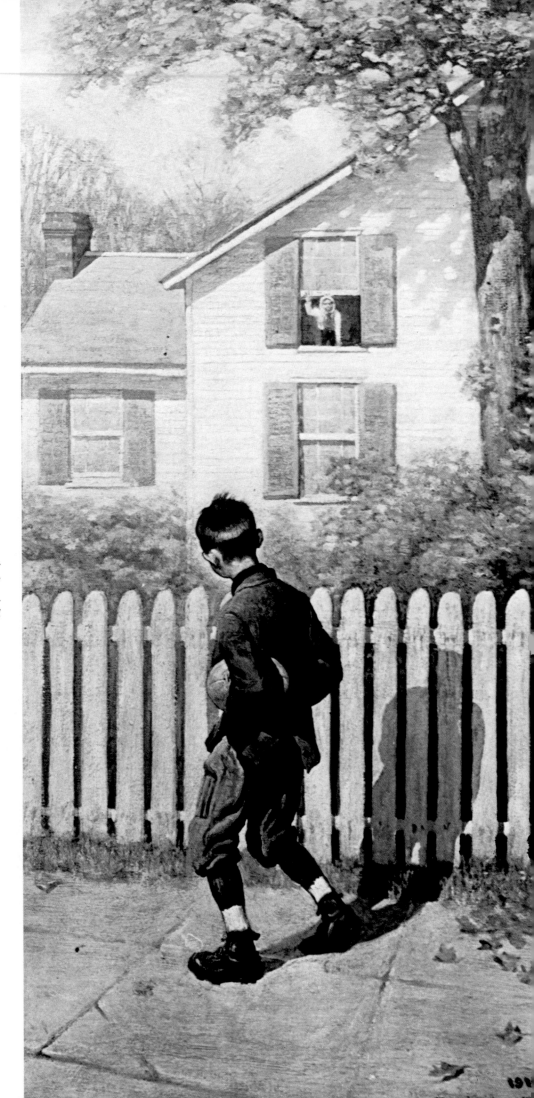

Illustration for
"The Magic Football,"
St. Nicholas, *December, 1914.*
Collection Norman Rockwell

Gramercy Park. *1918. Original oil painting. Collection Mr. and Mrs. George J. Arden*

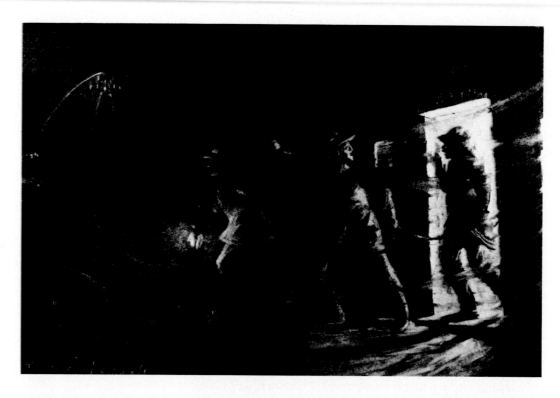

To the Rescue. *1916. Drawing. Collection Patricia and Howard O'Connor*

Party Line. *1918. Original oil painting.*
Collection Mr. and Mrs. Harold Konner

The pains Rockwell takes to find the right locations, props, models, and costumes are awe-inspiring: an illustration portraying Martha Washington in a 1939 issue of the *Ladies' Home Journal* was actually painted at Valley Forge; the clothes worn by the models who posed for *Tom Sawyer* and *Huckleberry Finn* were actually purchased off the backs and heads of the citizens of Mark Twain's home town, Hannibal, Missouri; Rockwell's home towns—New Rochelle, New York, Arlington, Vermont, and Stockbridge, Massachusetts—have provided a mob of friends, neighbors, and strangers to back up the professional models so that just the right type can be found for any situation.

The essential factor in understanding why so many people love his work is his own sincerity. Rockwell genuinely likes the people he paints and the people he paints for. When he is amusing them he is

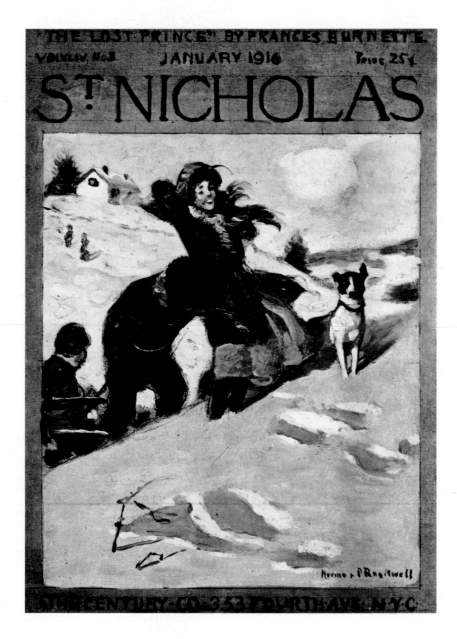

Winter. *Sketch for*
St. Nicholas *cover, 1916.*
Collection Saturday Evening Post

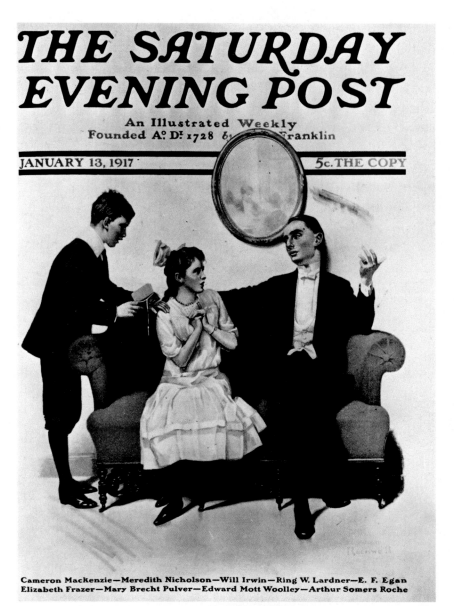

THE SATURDAY EVENING POST

An Illustrated Weekly
Founded A°. D°. 1728 by ... Franklin

JANUARY 13, 1917 5c. THE COPY

Cameron Mackenzie—Meredith Nicholson—Will Irwin—Ring W. Lardner—E. F. Egan
Elizabeth Frazer—Mary Brecht Pulver—Edward Mott Woolley—Arthur Somers Roche

Saturday Evening Post *cover,*
January 13, 1917

amusing himself. Long ago he made the following statement, which
was quoted in a 1923 issue of *International Studio*: "People some-
how get out of your work just about what you put into it, and if you
are interested in the characters that you draw, and understand them
and love them, why, the person who sees your picture is bound to
feel the same way." An artist's attitude undoubtedly has an impact
on his work no matter how professional he is. In Norman Rockwell's
case, his sincere interest in his subject causes him to learn a great
deal about it, to delve into the characters involved, to explore their
actions and reactions in terms of the situation he has conceived. This
leads not only to a remarkable degree of definition but also to a

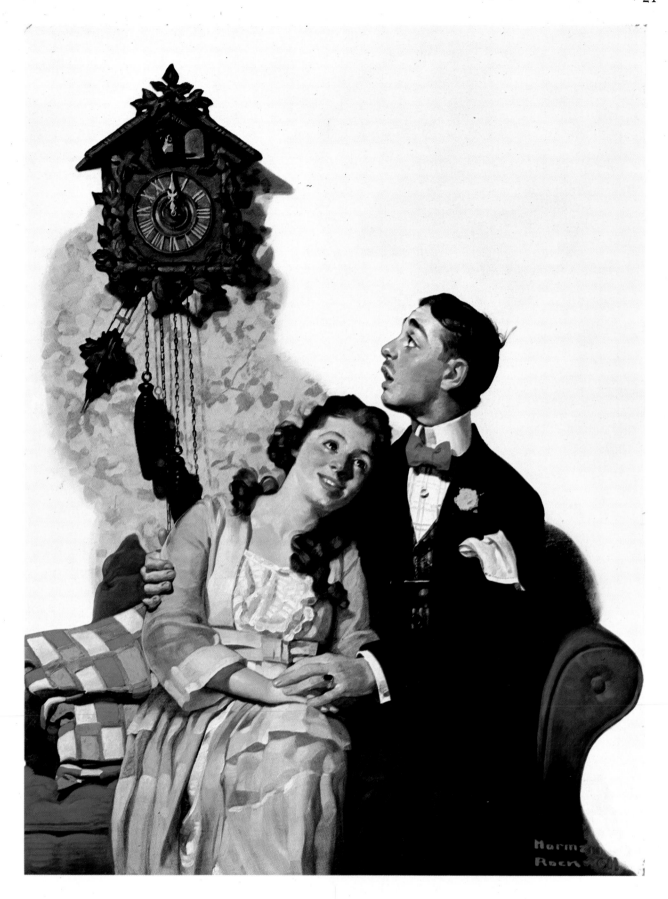

Courting Couple at Midnight. *Original oil painting for* Post *cover, March 28, 1919.*
Collection Harry N. Abrams, Inc., New York

Advertisement for Fisk bicycle tires, 1919

merging of characters and story. Rockwell returns to the same themes again and again, but because the people are different the whole situation is different.

And people, millions of them, enjoy his point of view. It is their point of view, full of things they remember or can imagine or would like to imagine. He does not try to change things; he invites people to chuckle, not to despair; to join the gang of regular fellows, not to stand alone; to reminisce, not to prophesy. He does not mean to confuse or challenge us; he certainly does not want to shock or offend; he rarely even raises a question.

Norman Percevel Rockwell was born on February 3, 1894, in a brownstone on 103rd Street and Amsterdam Avenue in New York City. His father, Jarvis Waring Rockwell, was the manager of the New York office of George Woods, Sons, and Company, a textile firm. According to Rockwell's autobiography, his father's family was "substantial, well to do, character and fortunes founded on three generations of wealth." In addition to reading Dickens aloud after dinner, Waring Rockwell also enjoyed copying illustrations from magazines.

Norman's mother, Nancy Hill Rockwell, was one of twelve children. Her father was an unsuccessful English artist who came to America shortly after the Civil War. "He hoped to open a studio as a portrait and landscape painter . . . instead he became a painter of animals, potboilers and houses. . . . He painted in great detail—every hair on the dog was carefully drawn; the tiny highlights in the pig's eyes—great, watery human eyes—could be clearly seen." Nancy's

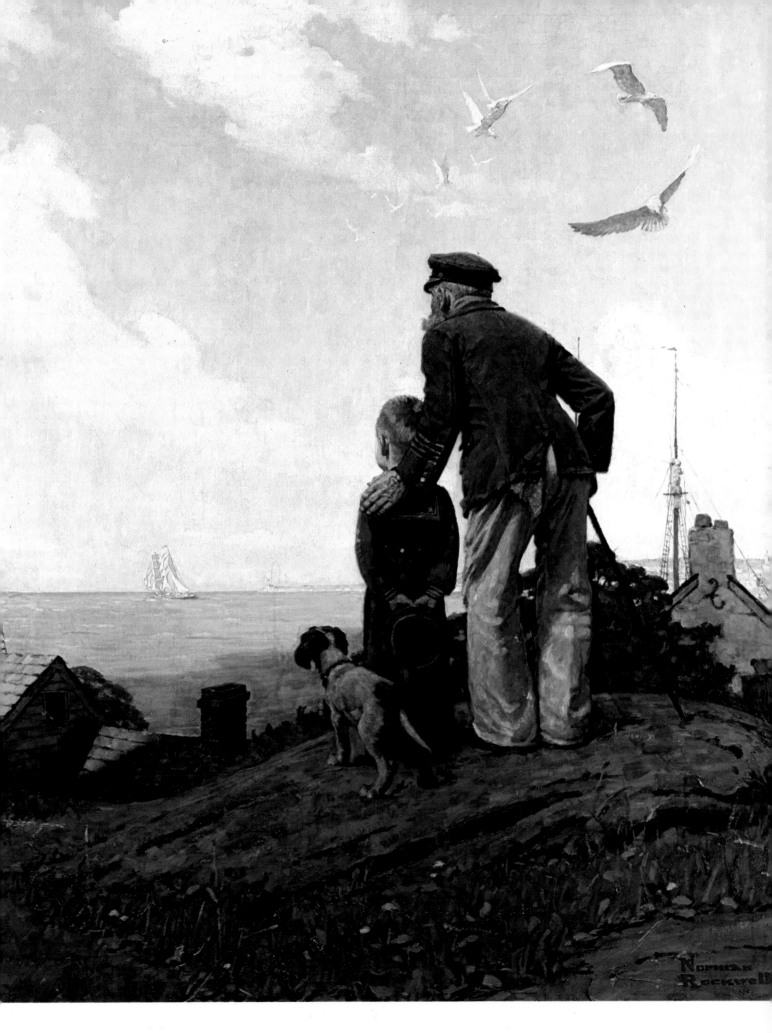

Looking Out to Sea. *1919. Original oil painting. Collection Norman Rockwell*

pride centered on her mother's family who traced their English ancestry back to Sir Norman Percevel. Norman, as the first son, received the entire ancestral inheritance—the name (his only brother was named Jarvis). Waring Rockwell was an aloof, gentlemanly father, Nancy a self-indulgent, complaining mother. Norman was never close to either of them. Interestingly, few of his storytelling covers dealt with parental relationships until he himself became a father.

The family was very religious. As a choirboy at St. Luke's and later at the Cathedral of St. John the Divine, Norman sang four services on Sunday after attending four rehearsals during the week. He also marched with a wooden gun in the St. Luke's Battalion. Thin, poorly coordinated, and pigeon-toed, he started wearing corrective shoes when he was ten, eye glasses at twelve. Unable to compete satisfactorily in sports, he used his drawing skill to entertain his contemporaries from an early age. He loved summers in the country and disliked the city, which he found dirty, sordid, and ugly. No theme is more dominant through the first three decades of his work than the idealization of boyhood in the summer in the country. It gradually expands to include adults, and other seasons, but very rarely do city streets appear.

In 1903, the Rockwell family moved to Mamaroneck, and by 1906 Norman had decided what he was going to be: ". . . boys who are athletes are expressing themselves fully. They have an identity, a recognized place among other boys. I didn't have that. All I had was the ability to draw, which as far as I could see didn't count for much. But because it was all I had I began to make it my whole life. I drew all the time. Gradually my narrow shoulders, long neck, and pigeon toes became less important to me. I drew and drew and drew."

By 1908, when he was fourteen, Rockwell commuted to New York on Saturdays and later, with the school principal's permission, on Wednesdays, for his first formal art training—at the Chase School of Fine and Applied Art. He left high school altogether in the middle of his sophomore year and switched to the National Academy School as a full-time student. As might be expected, the curriculum was academic in the grand French tradition. Students began by doing laborious charcoal studies from plaster casts of antique sculptures. When they had learned the fundamentals of proportion, anatomy, and rendering, they graduated to living models—male students in one classroom, female in another. The school was stiff, stilted, and oriented toward winning that classic scholarship, the Prix de Rome.

In 1910, Rockwell left and enrolled at the Art Students League. Founded in 1875, it was the most liberal and exciting art school of its day. Winslow Homer had studied there and so had Charles Dana Gibson, but of the long list of famous alumni none impressed Rock-

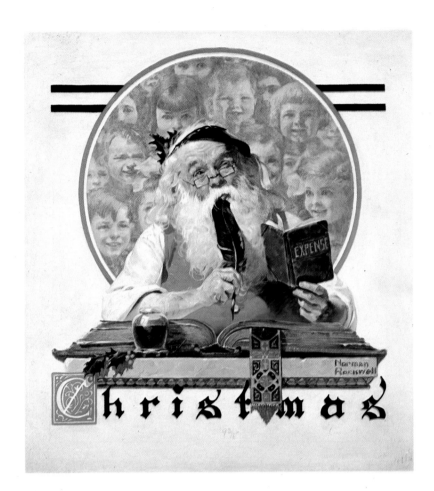

Santa. *Original oil painting*
for Post *cover, December 4, 1920.*
Collection Patricia and Howard O'Connor

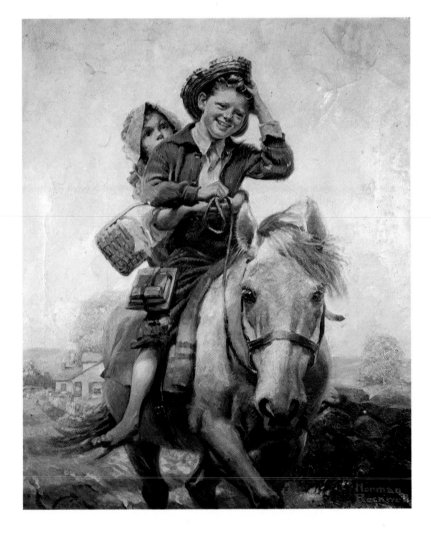

Boy and Girl on a Horse.
Original oil painting for
Literary Digest *cover, September 4, 1920.*
Collection Mrs. Elmer E. Putnam

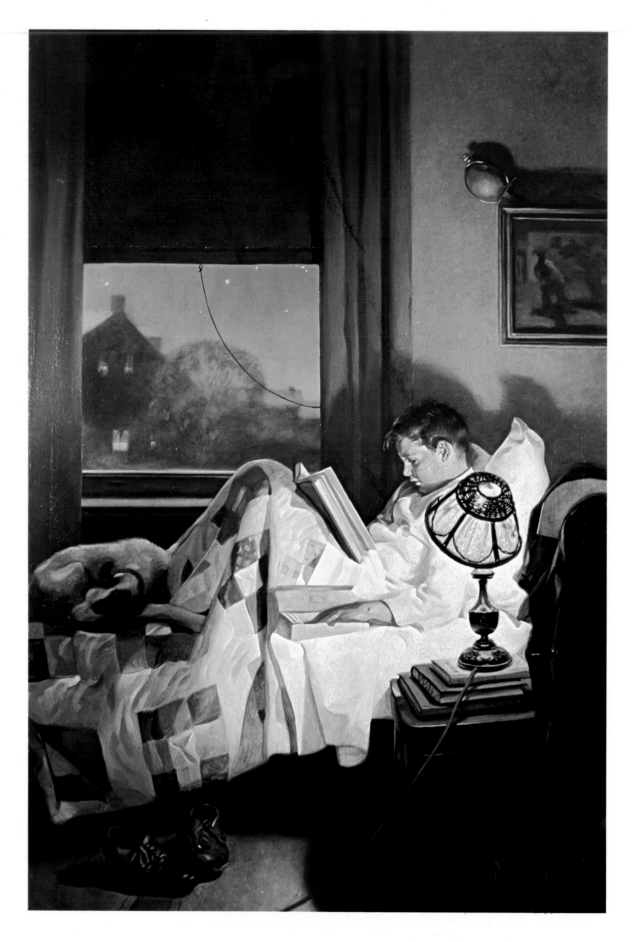

Crackers in Bed. *Original oil painting for advertisement for Edison Mazda Lamp Works, 1921.*
Collection Mr. and Mrs. George J. Arden

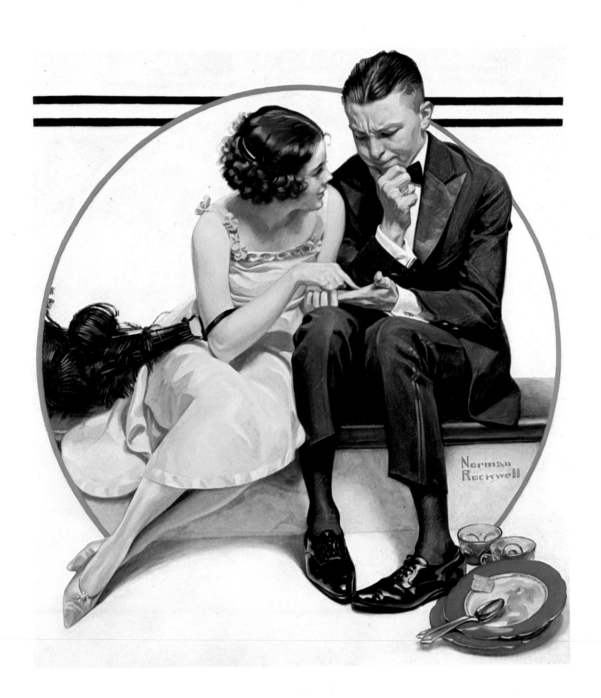

Fortune Teller. *Original oil painting for* Post *cover, March 12, 1921.*
Collection Mr. and Mrs. Jerome D. Mack

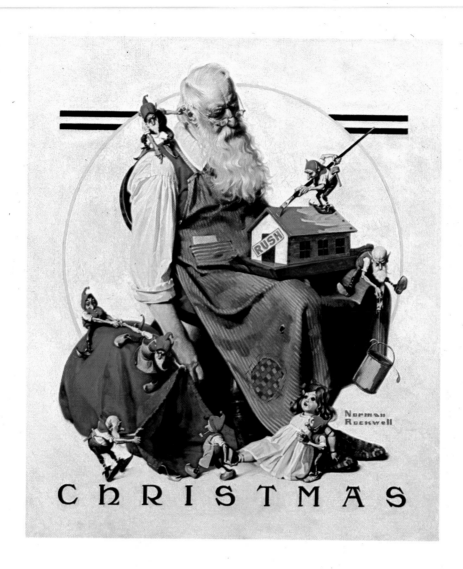

Christmas: Santa with Elves. *Original oil painting for* Post *cover,*
December 2, 1922. Collection Jarvis Rockwell

well more than Howard Pyle, one of the League's founders and the
greatest illustrator of his day. Pyle, historian as well as illustrator,
gave illustration scholarly status through his historical accuracy, and
drama through his portrayal of basic human emotion.

George Bridgman was Rockwell's great teacher. If Pyle's work
showed him where he wanted to go, Bridgman gave him the basic
equipment for getting there. "You can't paint a house until it's
built," he admonished his students. He taught construction: the
swivel, hinge, and arch of bone movement, the contraction, rest, and
extension of muscles. The body was studied in such detail that once
a student knew what any part of the model was doing, he could build
that part from the bone up and not have to depend on copying out-

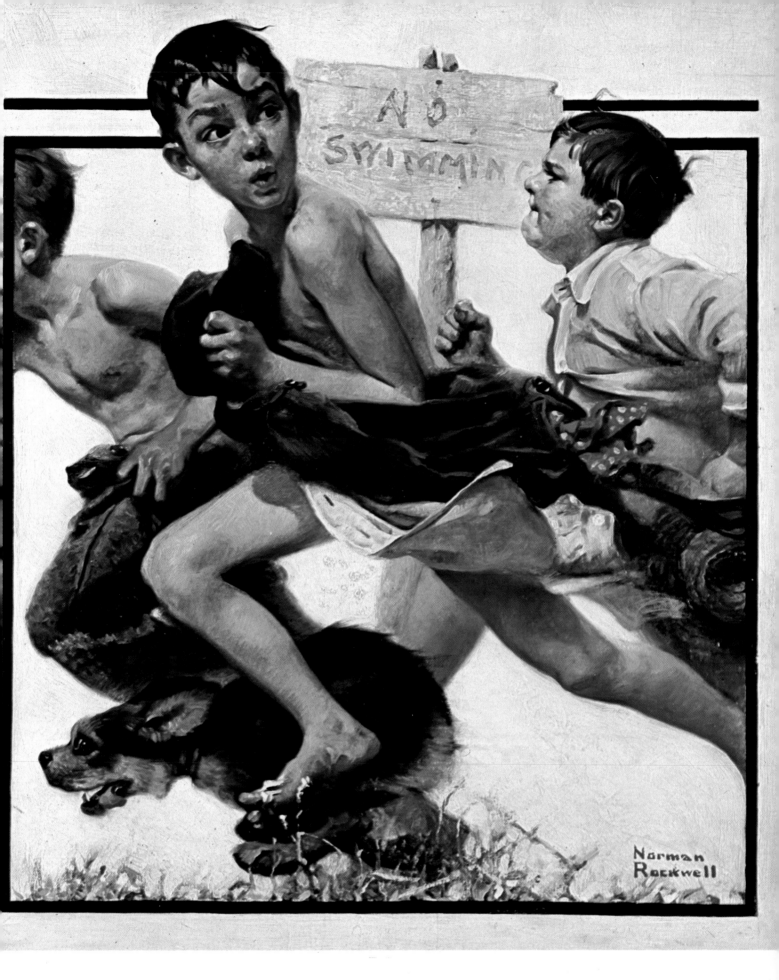

No Swimming. *Original oil painting for* Post *cover, June 4, 1921. Collection Norman Rockwell*

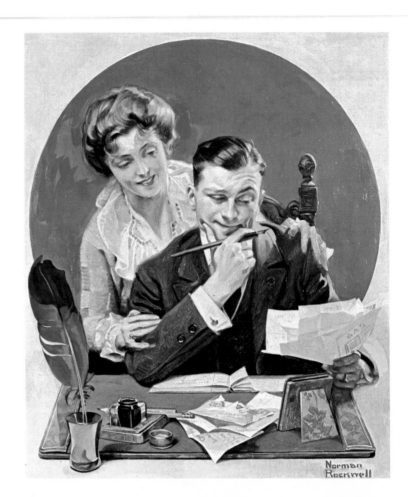

Paying the Bills.
Original oil painting for
Literary Digest *cover, February 26, 1921.*
Collection Mr. and Mrs. Jerome D. Mack

Waking Up Master. *1922. Oil on cardboard. Collection Patricia and Howard O'Connor*

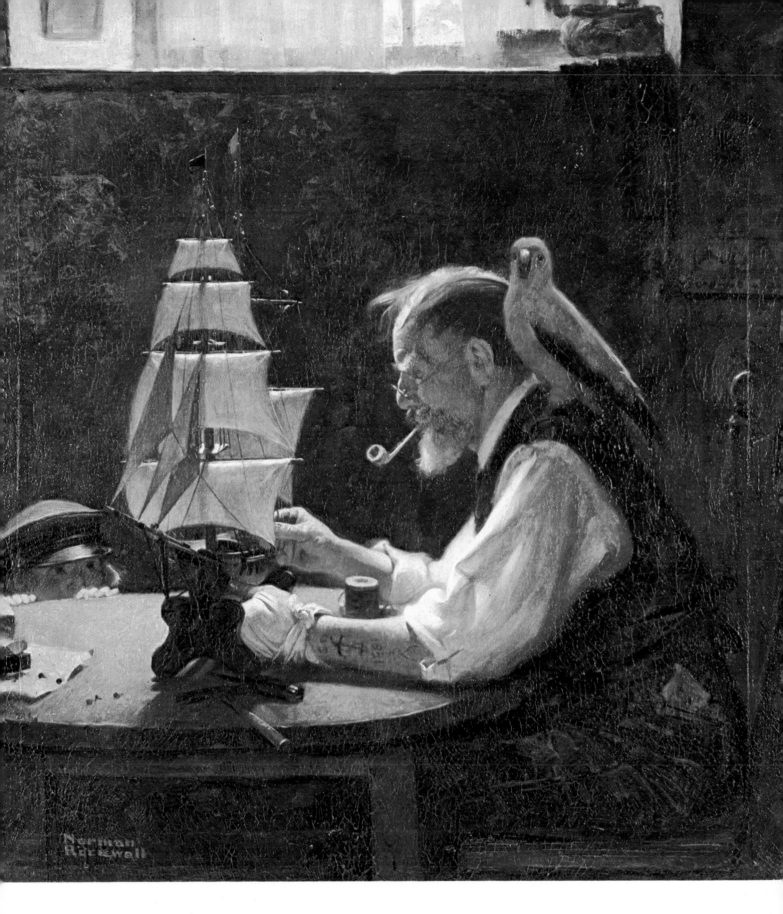

Old Sea Captain. *Original oil painting for* Literary Digest *cover, December 2, 1922. Private collection*

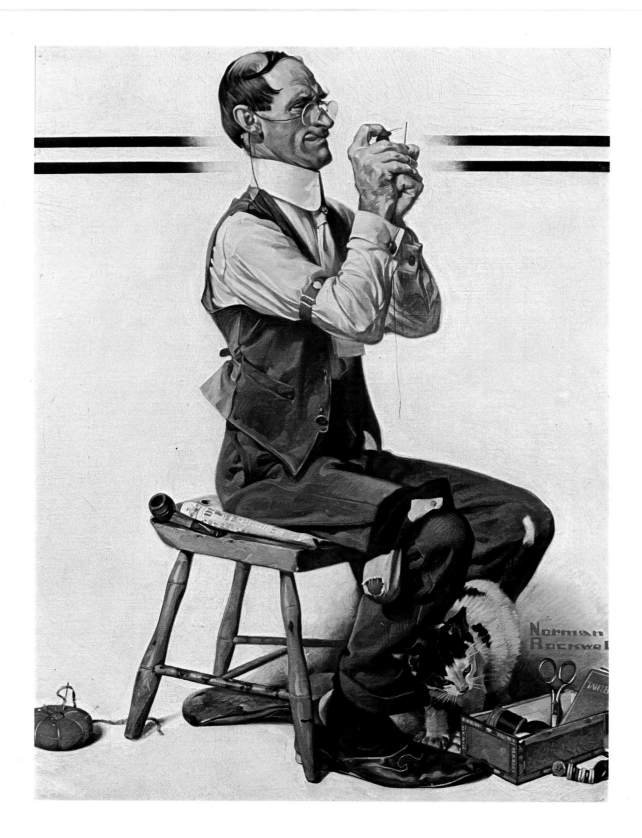

Man Threading a Needle. *Original oil painting for* Post *cover, April 8, 1922. Collection Kayser-Roth Hosiery Company, Inc., New York*

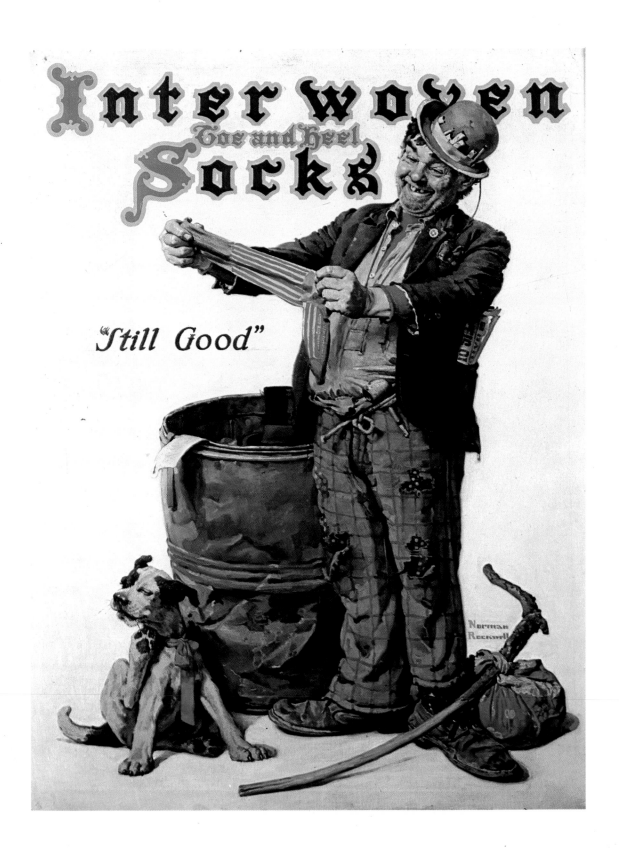

Still Good. *Original oil painting for advertisement for Interwoven socks, 1927.*
Collection Kayser-Roth Hosiery Company, Inc., New York

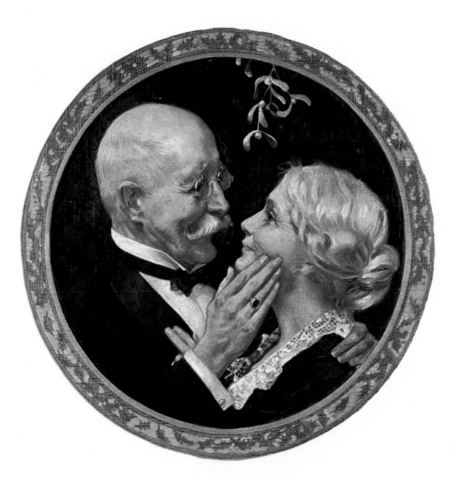

Under the Mistletoe.
1924. Original oil painting.
Collection Patricia and Howard O'Connor

Merry Christmas. *Original oil painting for* Post *cover,* ▶
December 8, 1928. Collection Mr. and Mrs. Murray L. Pfeffer

lines. The hands, particularly, in Rockwell's paintings illustrate how much he knows of complex anatomical construction. The fact that he does full-size charcoal drawings before he begins painting shows how seriously he took Bridgman's adage about building before painting. Arthur Burdett Frost, too, had a strong effect; from the very beginning, his careful selection of detail and infusion of quaint humor impressed Rockwell. He worked extraordinarily hard (as he still does) and what he learned he perfected, making each idea his own through the thoroughness of his study and consequent understanding.

Rockwell's other major teacher was Thomas Fogarty, who taught the illustration class. His definition of illustration was simple and straightforward: an author's words in paint. But from this basic approach evolved Rockwell's fascination with authenticity, characterization, supporting detail, and facial expression. In addition to analyzing the work of established illustrators—why they chose par-

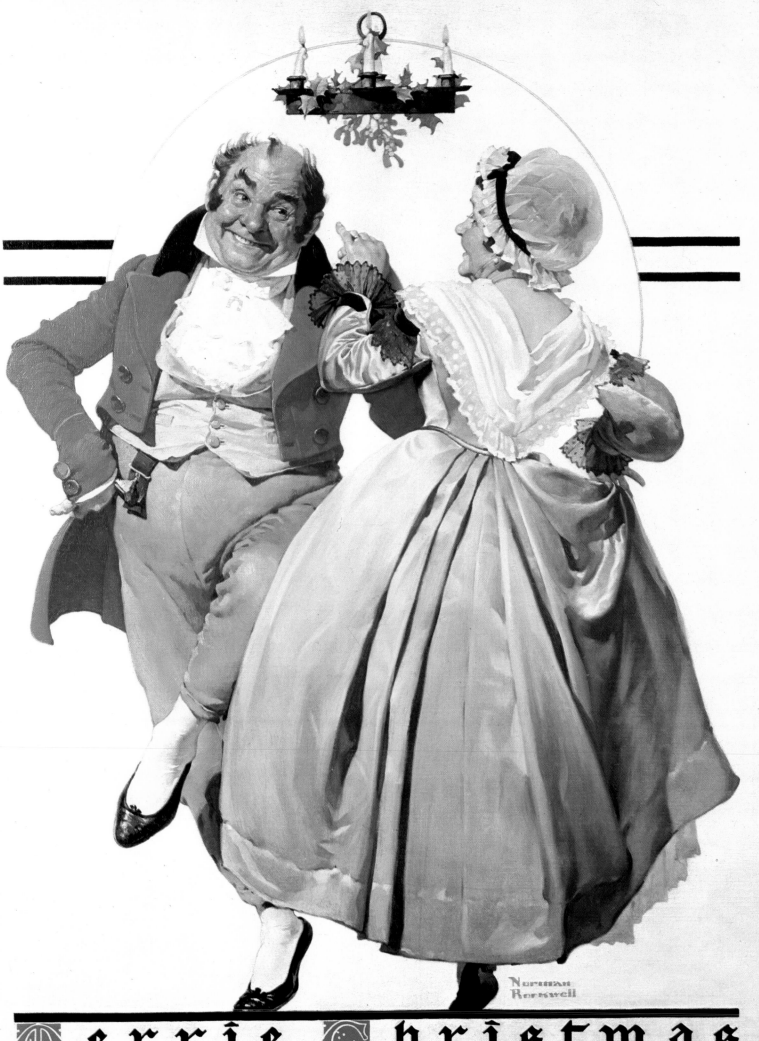

Merrie Christmas

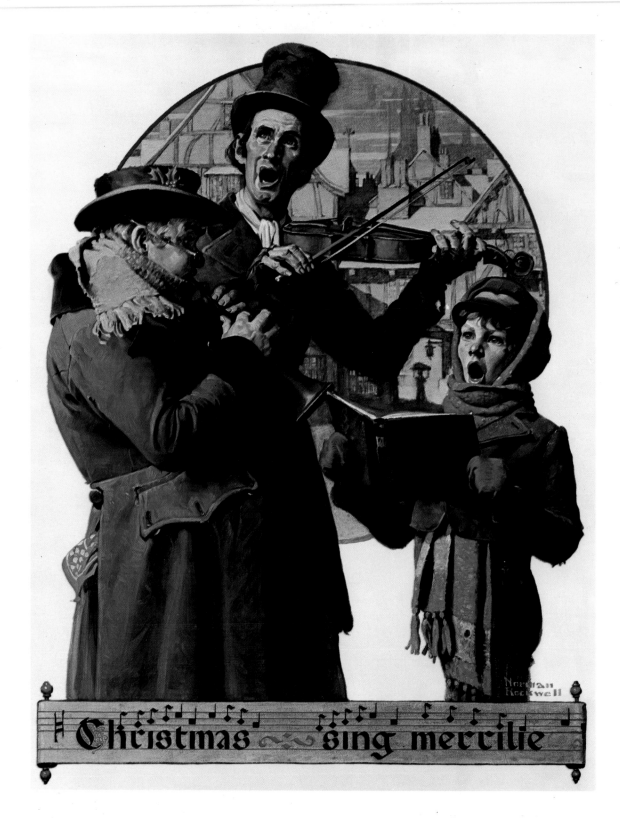

Christmas Trio. *Original oil painting for* Post *cover, December 8, 1923. Collection Norman Rockwell*

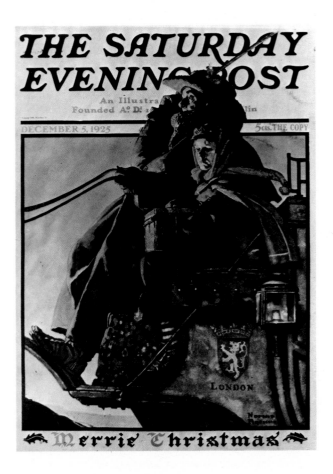

Saturday Evening Post *cover,*
December 5, 1925

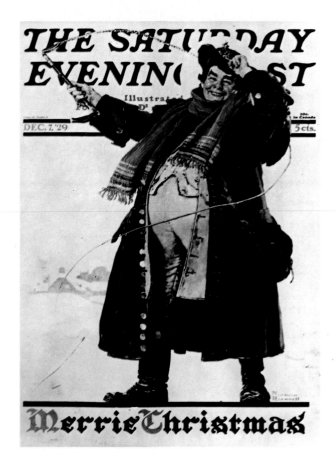

Saturday Evening Post *cover,*
December 7, 1929

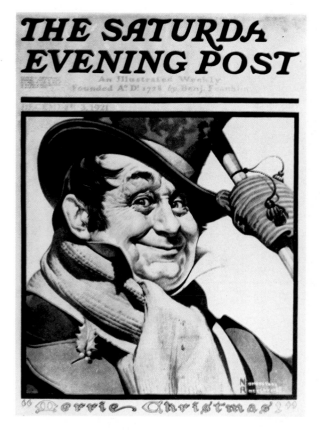

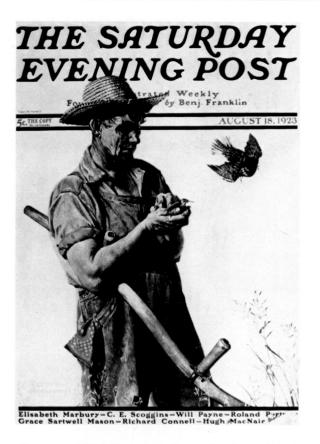

Saturday Evening Post *cover, December 3, 1921*

Farmer and Bird. Post *cover, August 18, 1923. Original oil painting, Collection William W. Waterman*

ticular passages to depict, why a dark instead of a light background, why pen and ink and not oils—Fogarty insisted that his students "live" in their illustrations. They had to know what kinds of people they were painting, why they were behaving as they were, what the weather was like, why they sat in a particular kind of chair—and so on. Obviously, Rockwell accepted Fogarty's lessons as he had Bridgman's, Pyle's, and Frost's.

During this brief period of training, Rockwell had a series of part-time jobs. As monitor the second year in Bridgman's class he had no tuition to pay and, as he continued to live with his parents, his expenses were modest. One summer he earned pocket money by being a paint-box caddy for Ethel Barrymore; during another he bought a mail delivery route in Orienta Point near Mamaroneck. In the winter, while a full-time student at the Art Students League, he worked as a waiter from 8:00 P.M. to midnight at a Child's restaurant then located near the League on Columbus Circle. This uninspiring occupation soon gave way to an exotic one—supernumerary at the Metropolitan Opera (his autobiography contains a delightful account of his relationship with Enrico Caruso). By 1912, when his family moved back to the city from Mamaroneck, illustrating jobs

were coming in fast enough to make other employment unnecessary. At eighteen he was a full-time professional.

Norman Rockwell develops his pictures in a series of separate, self-contained phases: first, a loose sketch of an idea; second, the gathering of models, costumes, background, and props; third, individual drawings of parts or, since about 1937, photographing everything; fourth, a full-scale drawing in great detail; fifth, color sketches; and sixth, putting all the parts together in the final painting. As with most artists, the procedure varies from picture to picture—he may do a whole series of compositional sketches in color or, at

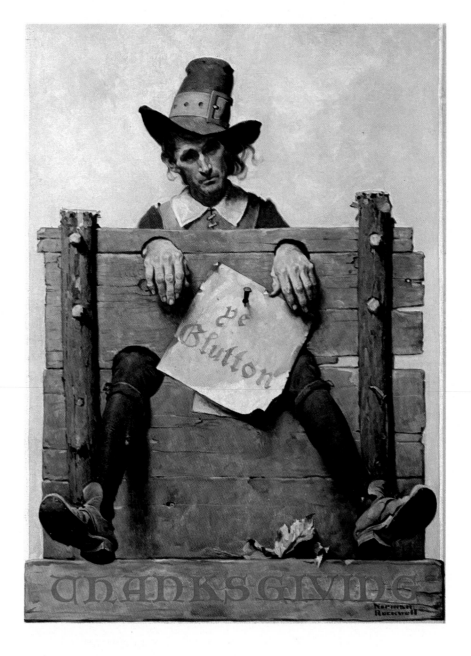

Thanksgiving (The Glutton).
Original oil painting for Life *cover,*
November 22, 1923.
Collection Harry N. Abrams, Inc.,
New York

In Need of Sympathy.
Original oil painting for Post *cover,*
October 2, 1926.
Collection E. A. Elder

Ben Franklin's Sesqui-Centennial.
Original oil painting
for Post *cover, May 29, 1926.*
Collection Mr. and Mrs. Joseph H. Hennage

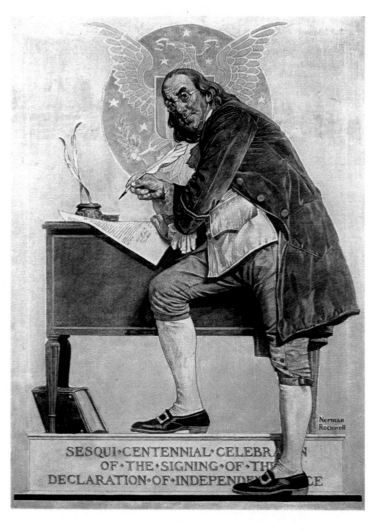

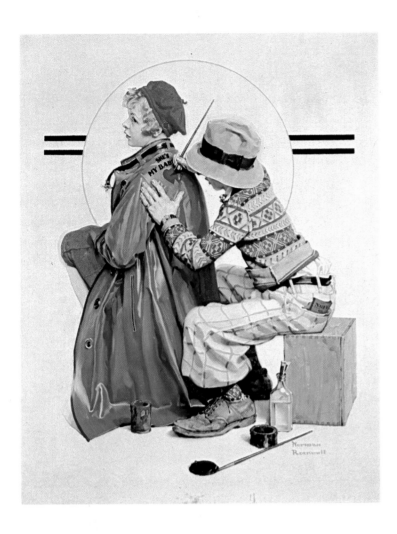

The Young Artist.
*Original oil painting
for* Post *cover, June 4, 1927.
Collection Mr. and Mrs. William M. Young, Jr.*

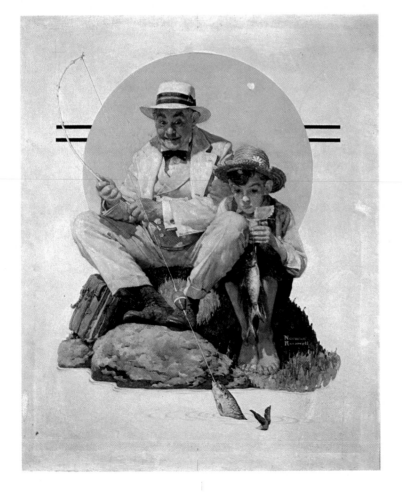

Catching the Big One.
Original oil painting for Post *cover,
August 3, 1929. Private collection*

the other extreme, simply project a photograph onto a white canvas, draw around the image and start painting. The one essential constant in his technique is the rigid separation of drawing and painting. He solves as many problems, makes as many decisions as he can in black-and-white and then takes on the color and textural possibilities of paint as the second phase. Having worked out all the details in black-and-white, he can concentrate fully on color and texture. The tight, frozen aspect of some of Rockwell's work probably comes more from working with photographs and striving for photographic realism than it does from the separation of drawing and painting.

But detailed attention to all parts—with extra attention given to faces—has been a Rockwell hallmark from the very beginning. Capturing just the right expression has long been one of his great if not unique strengths, and he worked hard to get it. In his early work he often overemphasizes what the facial features are doing in an effort to convey the proper emotion—particularly with children.

Norman Rockwell began by being successful. He executed his first commission before he was sixteen (four Christmas cards for Mrs. Arnold Constable), illustrated his first book when he was seventeen (*Tell Me Why Stories*), became art director of *Boys' Life* at nineteen, and reached the pinnacle of his profession by doing a cover for America's most popular magazine, the *Saturday Evening Post*, when he was twenty-two—at which point he married Irene O'Connor.

Illustrations for a book on Samuel de Champlain published in 1912 by the American Book Company were followed by a prodigious effort for Edward Cave, editor of *Boys' Life*: one hundred illustrations for the *Boy Scouts Hike Book* in 1913 and fifty-five more for the *Boys Camp Book* in 1914. In the same years he illustrated at least four novels by Ralph Henry Barbour and, as *Boys' Life* art director, did seventy-eight illustrations for that magazine in 1915 alone. During this period his drawings began to appear regularly in *St. Nicholas*, the *Youth's Companion, Everyland*, and the *American Boy*. Rockwell's productivity—enormous from the outset—began in the family apartment in Mamaroneck, but by 1912 he was in his first studio—the attic of a brothel on the Upper West Side. In less than a year he was in his second, near the Brooklyn end of the Brooklyn Bridge. His third studio was beside the boarding house in which his parents lived and the fourth was in New Rochelle, to which they moved in 1915.

The most important single event at this time was the publication of his first *Saturday Evening Post* cover, which appeared in print

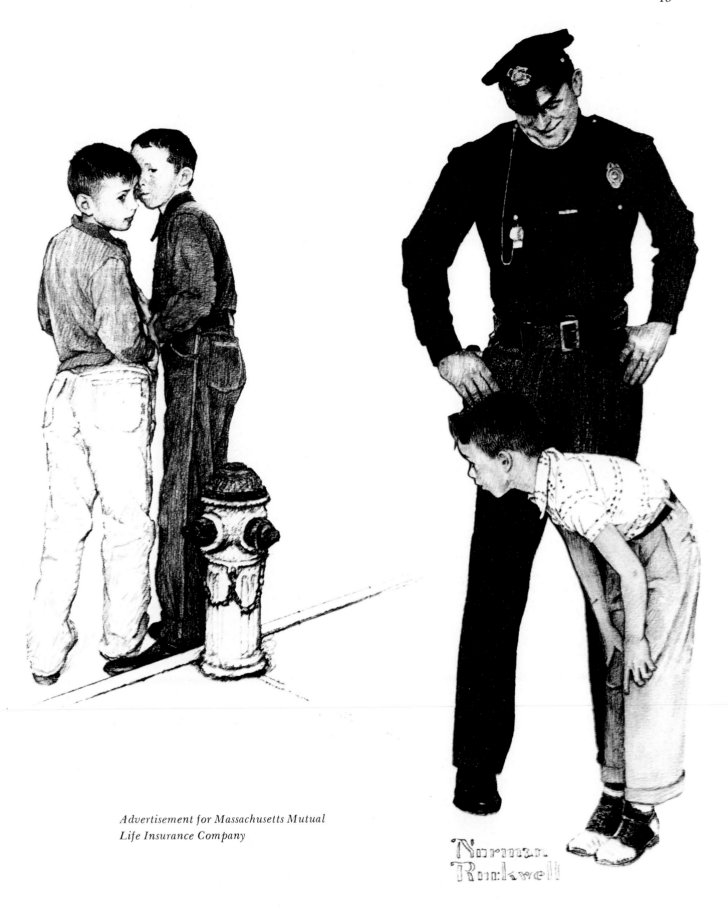

*Advertisement for Massachusetts Mutual
Life Insurance Company*

on May 20, 1916. He had done covers of the children's magazines for which he illustrated stories prior to his appearance on the *Post*. Immediately afterward, he began "covering" other national adult publications—many with *Post* rejects. *Collier's, Life* (then a humor magazine), *Leslie's, Judge, Country Gentleman*, the *Literary Digest, People's Popular Monthly, Farm and Fireside* (from Des Moines), and *Popular Science* were among them. He joined the Navy in 1917, and worked for *Afloat and Ashore* two days a week, did portraits of officers, and continued to serve his regular clients. The ever-present signature on covers done between July, 1917, and November, 1918, is sometimes followed by U.S.N.R.F. His first painting for advertisements also appeared during this period.

Certain themes emerge during this first decade that have provided Rockwell with subject matter for more than half a century. They are interesting to follow because his treatment of them changes as he grows older. Other themes are less enduring, and new ones appear all along the way. Situations involving small embarrassments, discomforts, and humiliations have provided humorous covers all the way through. Growing up is another and, closely related, is budding love. Old-fashioned patriotism persists as well as the recording of fads and historical events. Youth contrasted with age is a major

Saturday Evening Post *cover, November 10, 1923* Saturday Evening Post *cover, April 5, 1924*

category, recurring almost as often as depictions of simple joys for the vicarious delight of the reader. More specific long-term subject matter introduced in this first decade includes, in order of appearance, Santa Claus, Boy Scouts, circus people, dogs, and bandaged big toes. Rockwell's particular ability to combine humor and pathos has not yet appeared as a strong characteristic.

During the twenties, Rockwell became rich and famous. He took up golf and sailing, joined clubs, found his own bootlegger, and spent as much time partying as painting. He toured South America and steamed back and forth across the Atlantic six times. He saw students dueling in Heidelberg, Riffs rebelling in Morocco, and Venezuelans revolting in Caracas. He was accepted by society, pursued by publishers, and divorced by Irene. His work continued to improve.

He became the top cover artist for the *Saturday Evening Post*. His work appeared almost every month, and beginning in 1919 he did a Christmas cover every year without interruption until 1943— but he was tempted by other offers. In 1924, Patterson and McCormick in Chicago founded *Liberty* in competition with the *Post* and *Collier's*. The art director of the new magazine came to New

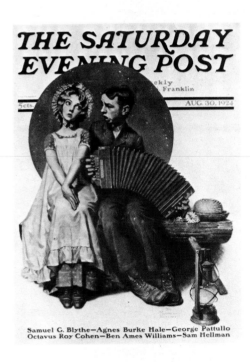

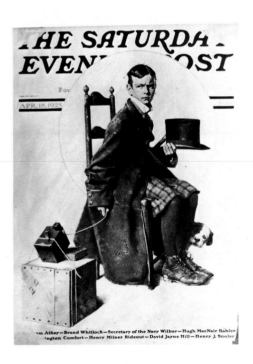

Saturday Evening Post *cover, August 30, 1924*　　Saturday Evening Post *cover, April 18, 1925*

Saturday Evening Post *cover,*
August 13, 1927

Rochelle and offered to double whatever the *Post* was paying. Rockwell hesitated, went to Philadelphia, and described the situation to George Horace Lorimer, *Post* editor from 1899 through 1936. Mr. Lorimer's only response was to ask Rockwell what he had decided to do. He decided to stay and Mr. Lorimer decided to double his price. Rockwell's respect for George Horace Lorimer is awesome—no other personality in his autobiography is the subject of such thorough admiration. After this meeting, he illustrated very few covers for other magazines but took on more advertising—at twice his fee for a *Post* cover.

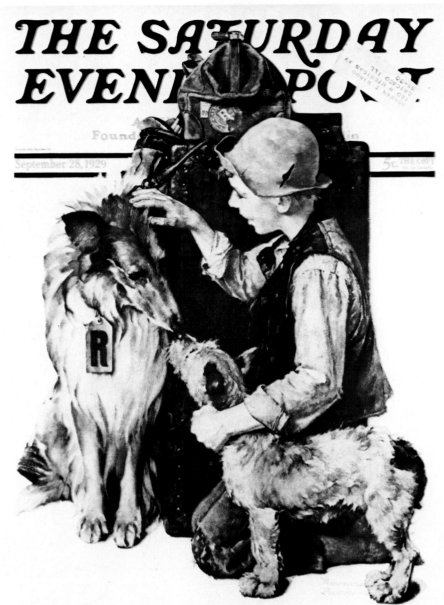

THE SATURDAY EVENING POST

Founded

September 28, 1929 5c. THE COPY

A. Conan Doyle—Margaret Weymouth Jackson—Edith Fitzgerald
Frederick Irving Anderson—Don Marquis—Gilbert Seldes—Sophie Kerr

Raleigh Rockwell Travels.
Post *cover, September 28, 1929.*
Original oil painting,
Collection Patricia and
Howard O'Connor

Things were happening fast in the twenties: new clothes, new
music, new morals, new art. While in Paris in 1923, Rockwell had
enrolled in Colarossi's school. His Bridgman-Pyle approach sud-
denly seemed hopelessly old-fashioned. He tried to do a "modern"
cover emphasizing abstract color. It was rejected by the *Post* and he
settled back into what he loves best, telling stories. In a sense, he
became two artists and painted in two quite separate styles. One was
in the Victorian tradition, sentimental and pretty, full of atmos-
phere and charm—a direct link with the past and extremely well
done. The other style reflected the changes that were taking place:

Illustration for "A Christmas Reunion,"
Ladies' Home Journal, *December, 1927*

Advertisement for Maxwell House coffee

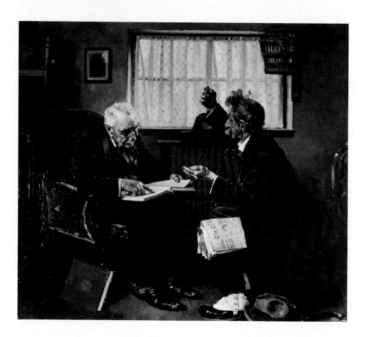

Advertisement for the Encyclopaedia Britannica

Man Painting Flagpole. *Original oil painting for* Post *cover, May 26, 1928. Collection the McCullough Family* ▶

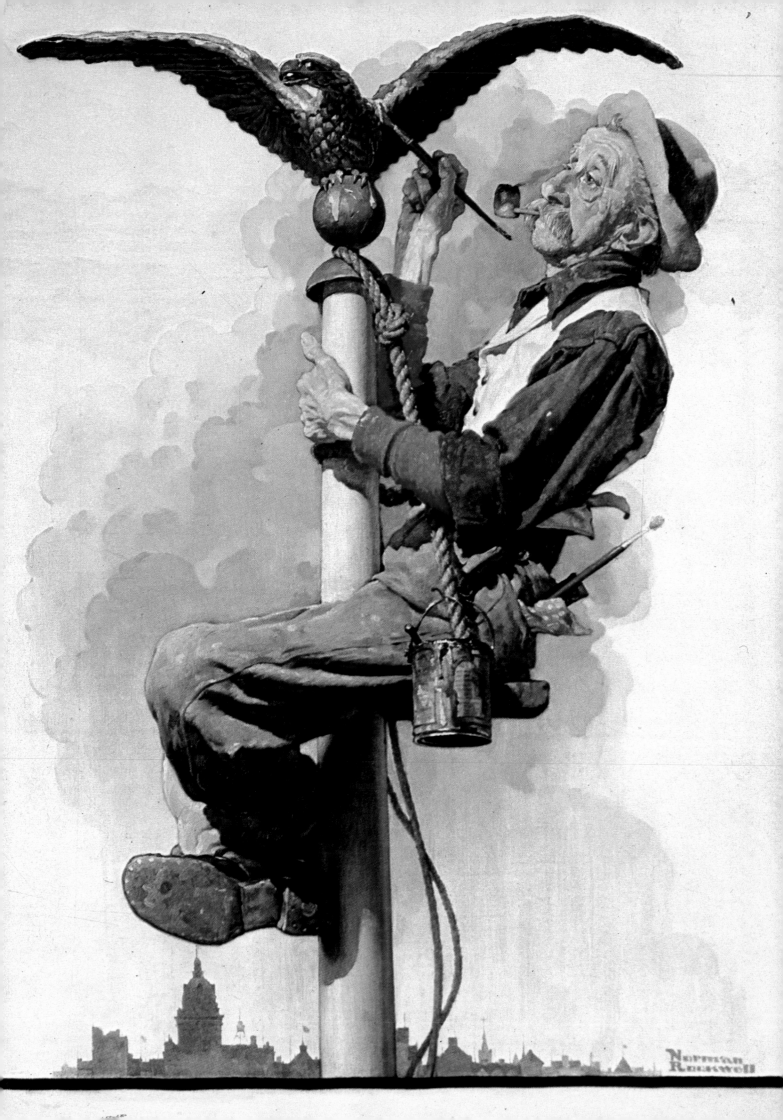

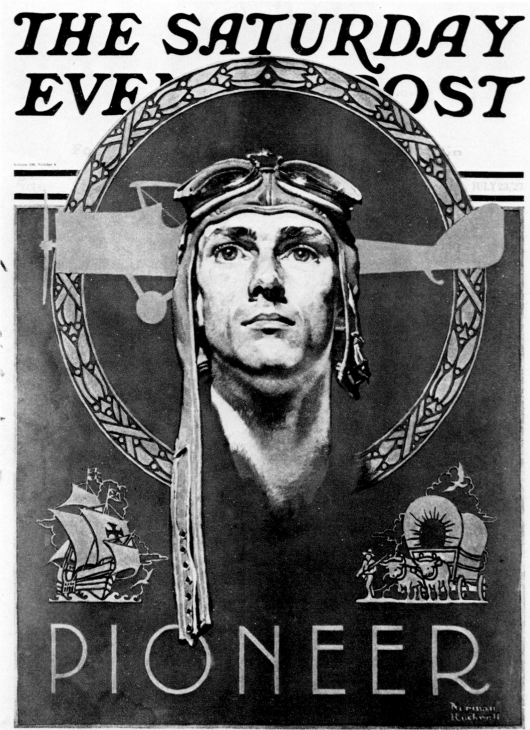

Saturday Evening Post *cover, July 23, 1927*

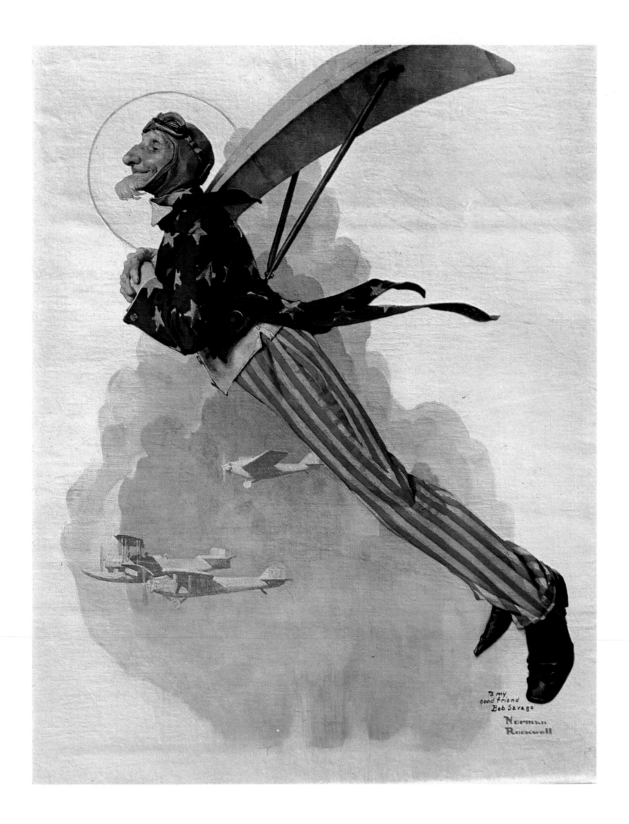

Uncle Sam. *Original oil painting for* Post *cover, January 21, 1928. Collection Paul C. Wilmot*

strong silhouettes backed by simple geometric shapes—Art Deco circles and squares, design instead of atmosphere, character instead of idealization, humor instead of sentiment.

Norman Rockwell's subject matter also changes radically during this period. Although children continue to predominate (90 per cent of the *Post* covers illustrated from 1916 to 1919 included children, 50 per cent from 1920 to 1929), the approach changes from that of a boy describing himself to a man looking back on boyhood. More important is the appearance of two new elements in the Rockwell approach. The first is the outside character, who is not one of us and at whom we can laugh; the second is what might be called "pathotic" humor (or humorous pathos). The latter element, pathotic humor, seems almost to have been introduced in order to avoid the danger of derisive laughter. Ridicule is not consistent with Rockwell's personality, and although the characters invite amusement they remain sympathetic, simultaneously funny and sad. Mixing tears and laughter is a delicate job, and the picture that evokes a strong feeling of commiseration can be as successful as the side-splitter. The *Saturday Evening Post* covers painted by Rockwell during the twenties introduced many new subject areas and formats, and several characters that would recur frequently: bums, sheriffs, musicians, and doctors.

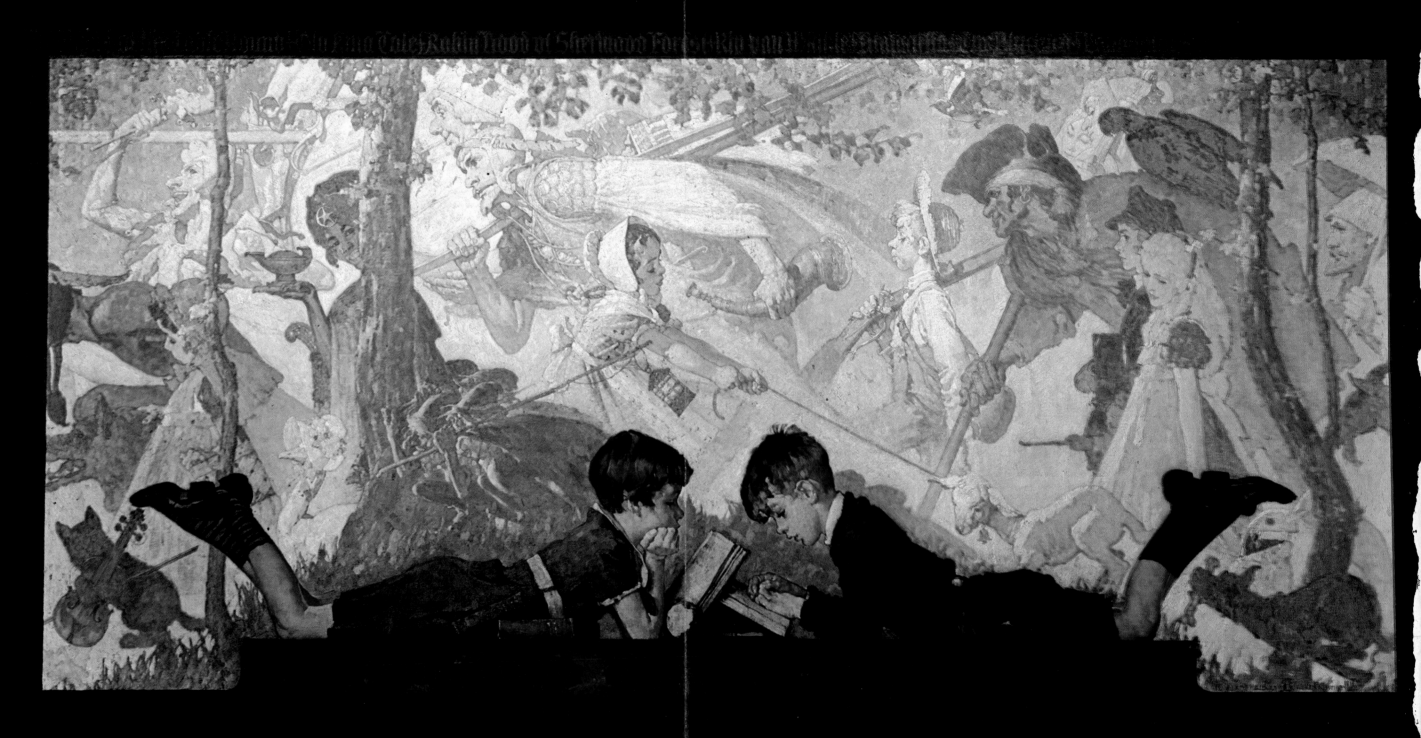

THE LAND OF ENCHANTMENT

Original oil painting for Post *illustration, December 22, 1931.*
Collection New Rochelle Public Library, New York

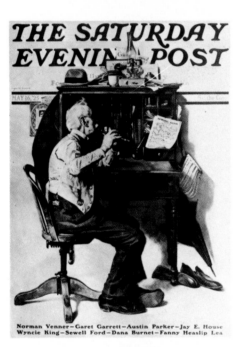

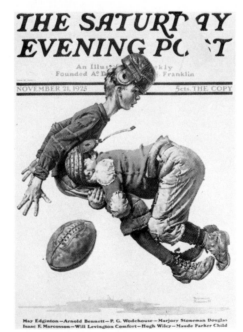

Saturday Evening Post *covers, September 27, 1924–November 21, 1925*

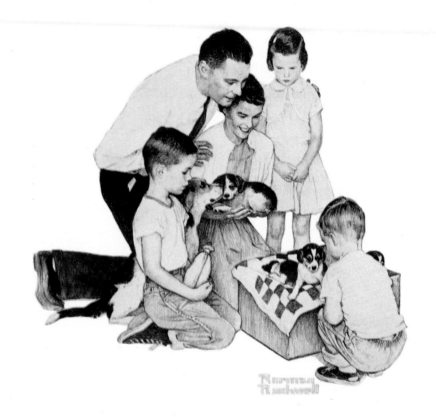

*Advertisements for
Massachusetts Mutual Life
Insurance Company*

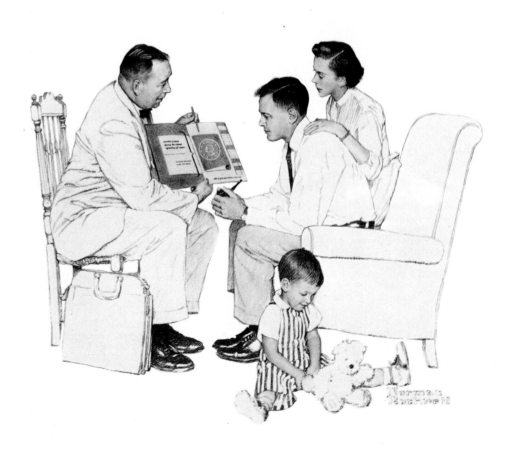

1930 - 1949

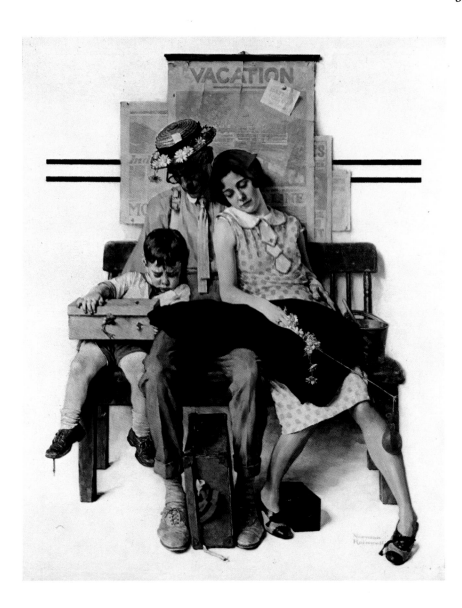

Home from Vacation.
*Original oil painting
for* Post *cover, September 13, 1930.*
Collection Mr. and Mrs. Phil Grace

I N THE THIRTIES, ROCKWELL BEGAN PAINTING FROM PHOTOGRAPHS, re-
turned to illustration, married, and had three sons. From a miserable
bachelorhood at the Hotel des Artistes at Sixty-seventh Street and
Central Park West following his divorce, he fled to Los Angeles to
escape the art editor of *Good Housekeeping* who insisted he illus-
trate the life of Christ. There he painted Gary Cooper for the May
24, 1930, cover of the *Post* and married Mary Barstow. Back in New
Rochelle at 24 Lord Kitchener Road he began to have trouble with
his work. Waning self-confidence, indecision, and procrastination
reduced both the quality and quantity of his output. He experi-
mented with dynamic symmetry, had another modern art approach
rejected, and, in real desperation, left his own charming world for
the sordid and ugly: he painted a dead gangster—never published
and now lost. In 1932, the Rockwells went to Paris with their newly
born first son, Jerry.

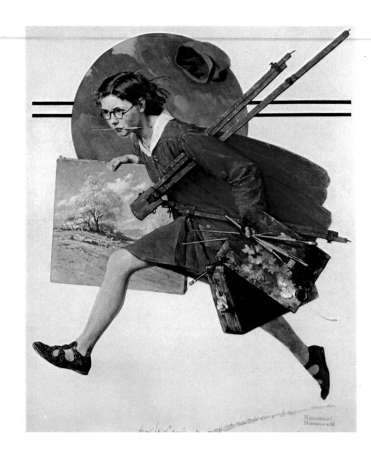

Wet Paint. *Original oil painting*
for Post *cover, April 12, 1930.*
Bernard Danenberg Galleries, Inc., New York

Gary Cooper as the Texan.
Original oil painting for
Post *cover, May 24, 1930.*
Collection Mr. and Mrs. Walter J. Rephun

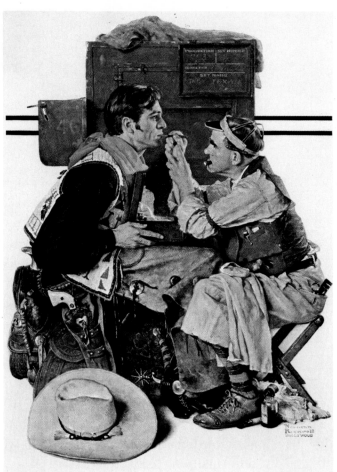

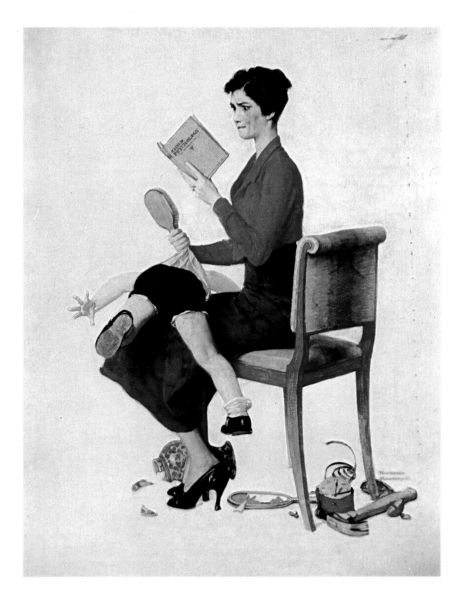

Mother Spanking Her Child.
*Original oil painting
for* Post *cover, November 25, 1933.
Collection the McCullough Family*

The turning point was 1935. Almost as if he had been saving up for it, Rockwell suddenly began to pour out some of the finest work he has done: illustrations for *Tom Sawyer, Huckleberry Finn,* the life of Louisa May Alcott, the Yankee Doodle mural for the Nassau Tavern in Princeton, and a superb series of magazine illustrations. The *Post* covers done between 1936 and 1939 include some of his very best work.

For purposes of authenticity (if not escape) he traveled whenever possible to the actual site where the story he was to illustrate took place. The whole family traveled to England in 1938, and Rockwell met some of his famous colleagues—Arthur Rackham among them. Twenty-three years earlier, Rockwell had illustrated *The Magic Football* for *St. Nicholas* magazine; Rackham had done the frontispiece for the same issue. During all that period—from *Don*

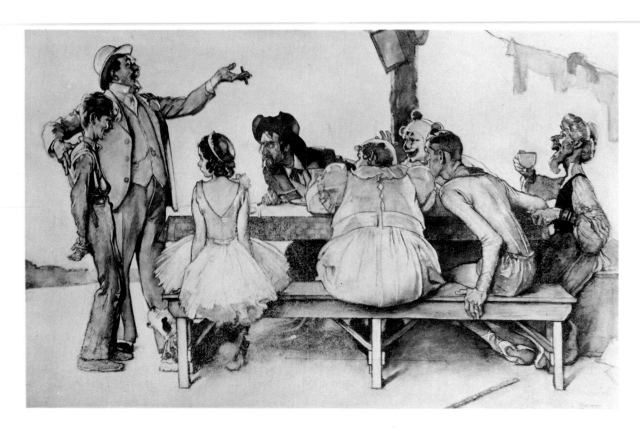

Charcoal drawing for "Willie Takes a Step" by Don Marquis, American, January, 1935. Collection Mr. and Mrs. Carl Wulff

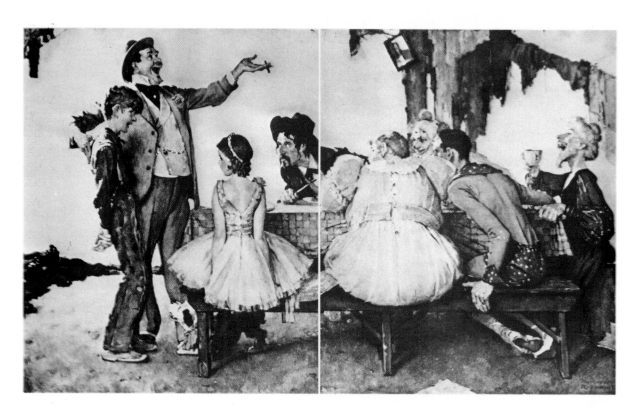

Final illustration for "Willie Takes a Step" by Don Marquis, American, January, 1935. Whereabouts unknown

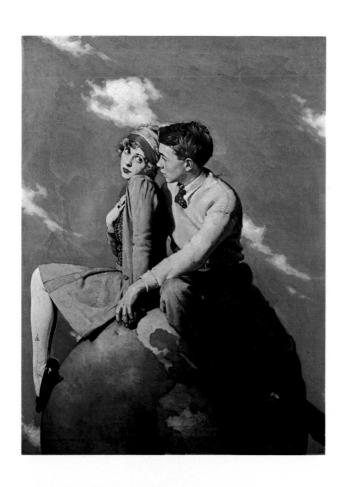

On Top of the World.
Original oil painting for Ladies' Home Journal, *1933.*
Collection Harry N. Abrams, Inc., New York

Playing Checkers. *1935. Original oil painting.*
Collection Mr. and Mrs. Gustave Seaberg

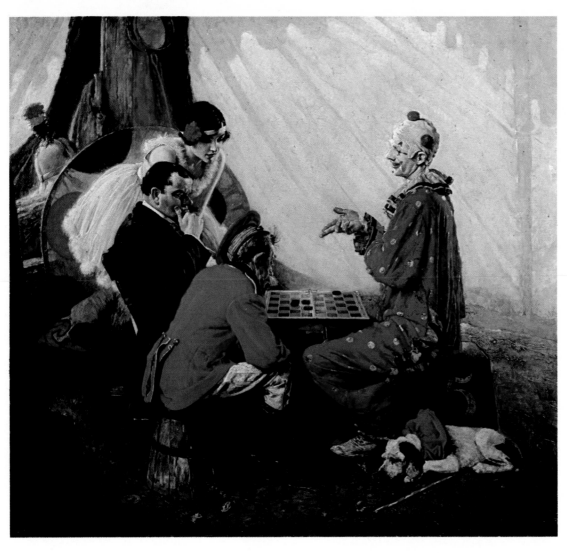

Barbershop Quartet.
Sketch for Post *cover, September 26, 1936.*
Collection Arts International Ltd., Chicago

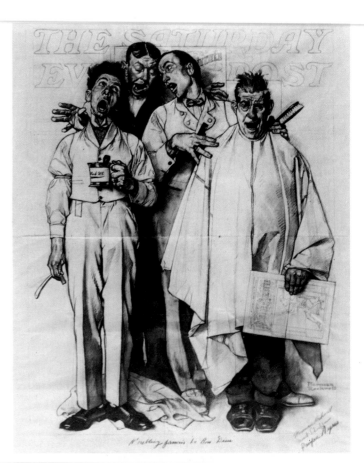

Boy Flying Kite. *1930s. Drawing.*
Collection Dr. Robert Bakish

Barbershop Quartet.
Original oil painting for Post *cover, September 26, 1936.*
Collection Mr. and Mrs. J. William Holland

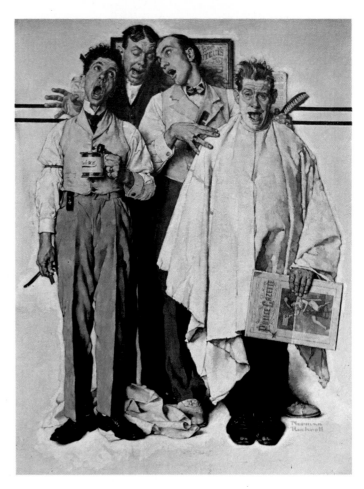

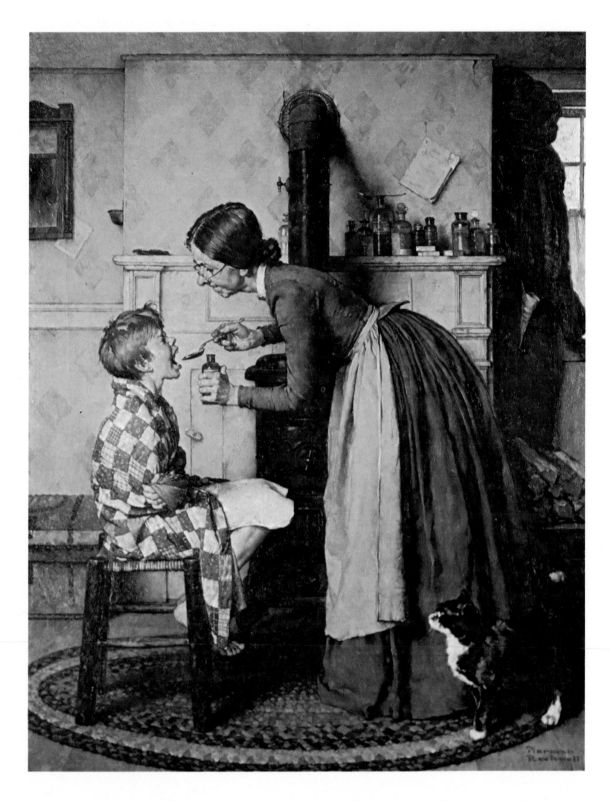

Spring Tonic. *Original oil painting for illustration to* The Adventures of Tom Sawyer, *1936.*
Collection John C. Meeks

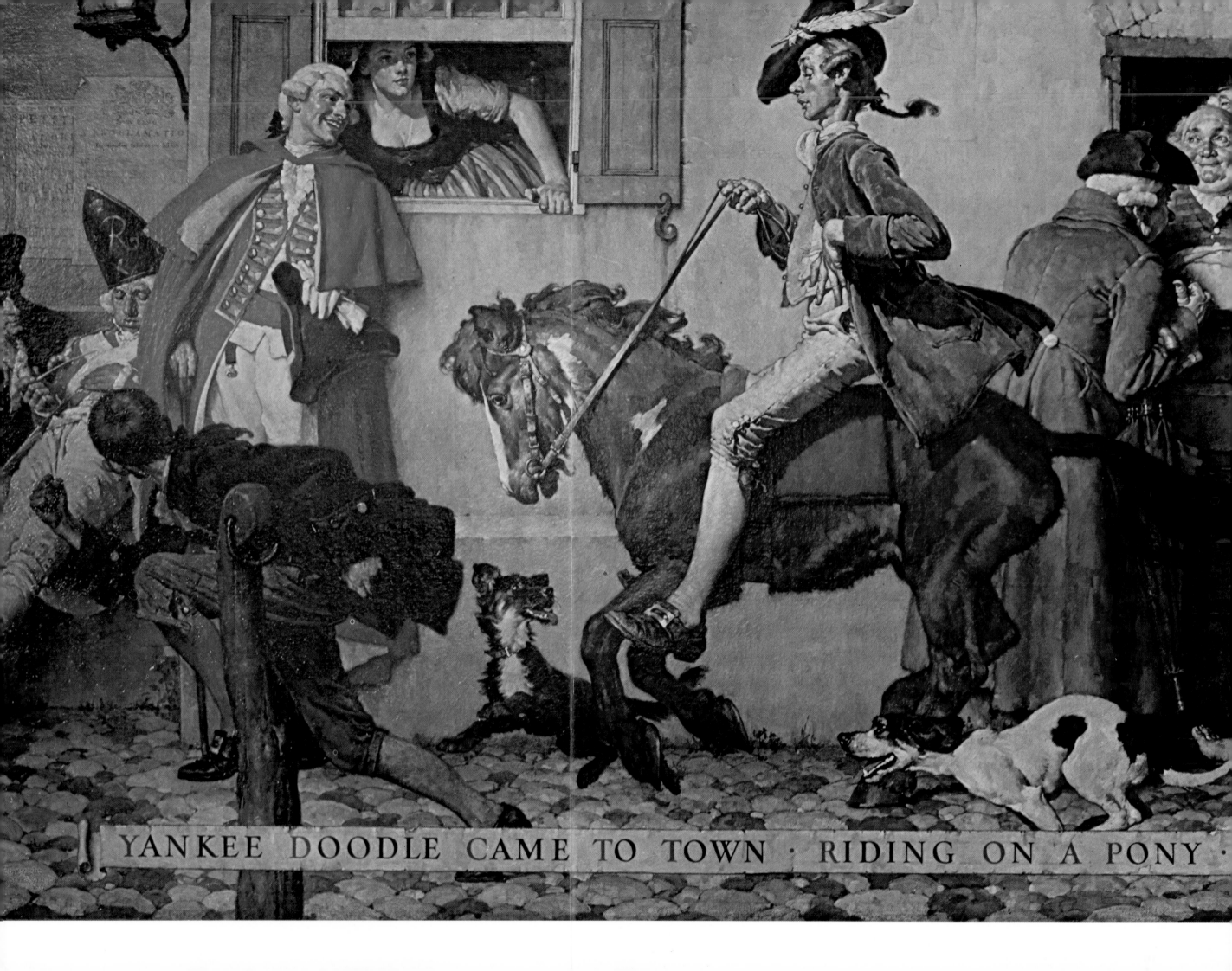

YANKEE DOODLE CAME TO TOWN · RIDING ON A PONY

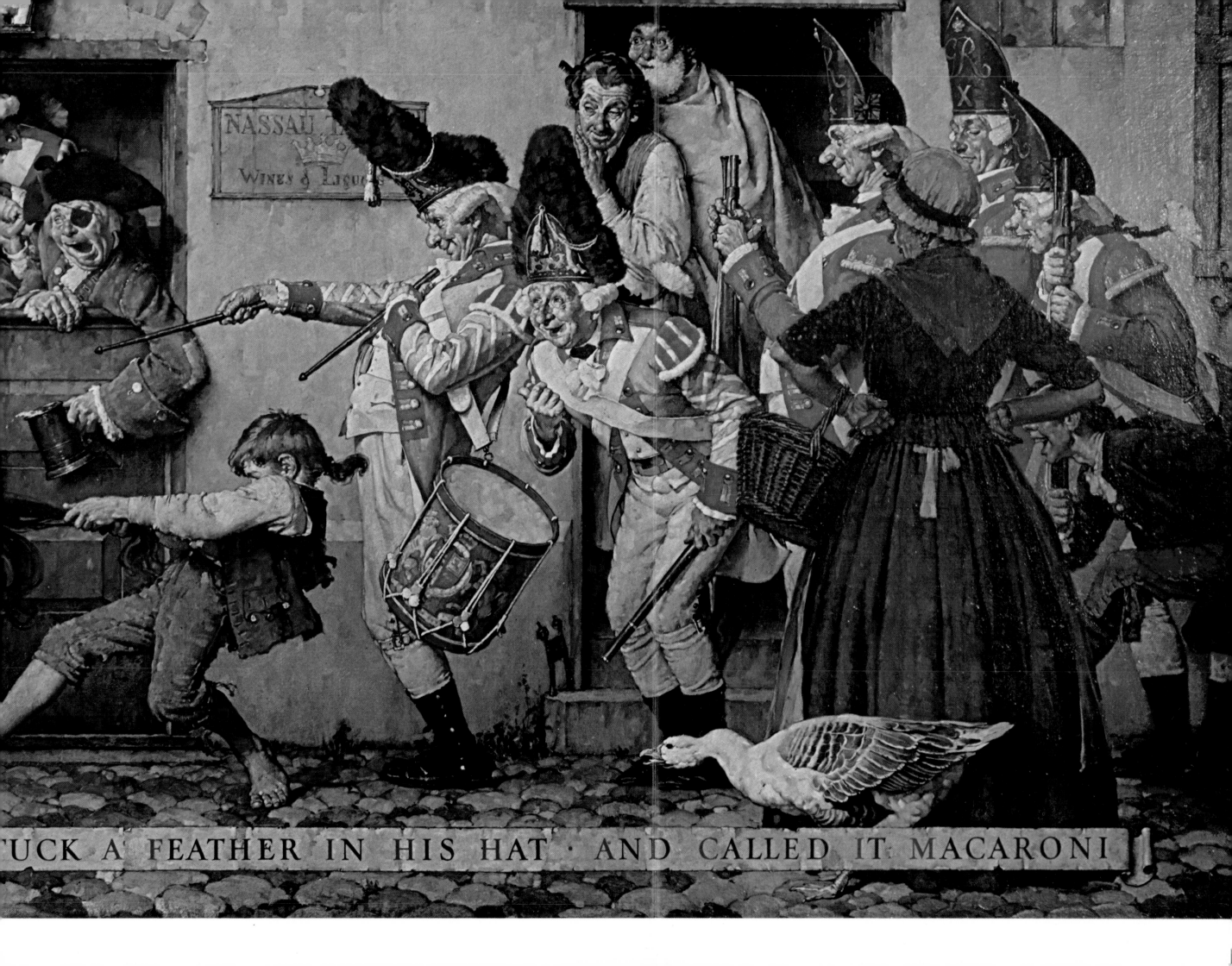

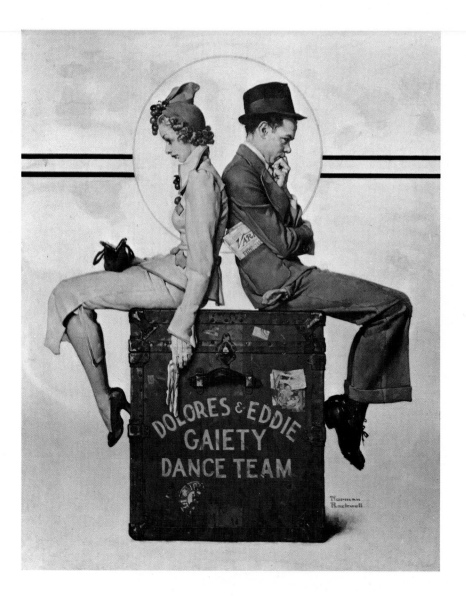

Gaiety Dance Team. *Original oil painting for* Post *cover, June 12, 1937.*
Collection Variety, *Inc., New York*

◀ YANKEE DOODLE

Mural for the Nassau Tavern,
Princeton, New Jersey. 1937

Strong of the Wolf Patrol to the Nassau Tavern mural—Rockwell
had lived in New Rochelle. In 1939 the family moved to Arlington,
Vermont.

The two major factors affecting Rockwell's work of the thirties
are a new interest in illustrating other people's stories and a final
surrender to the convenience of the camera. The photographer
starts to help about 1937, but illustrations were painted both from
living models and from photographs. There is an important but
hard-to-define difference. Those painted from photographically sup-
plied information are generally more realistic; forms look flatter,
they do not have the same sense of bulk, and, in the beginning at
least, the details contribute little to the quality of the design; indi-
vidual items become less important, and the eye wanders more freely

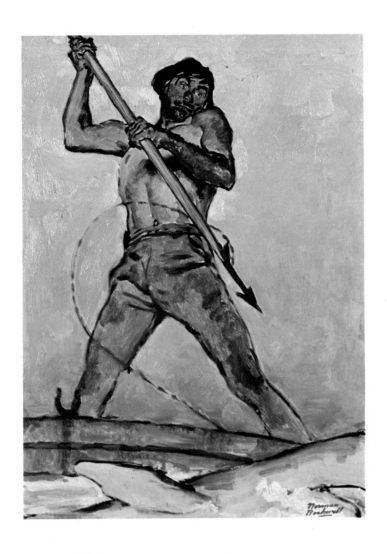

Harpooner.
1938. Drawing.
Collection Mr. and Mrs. Thomas Rockwell

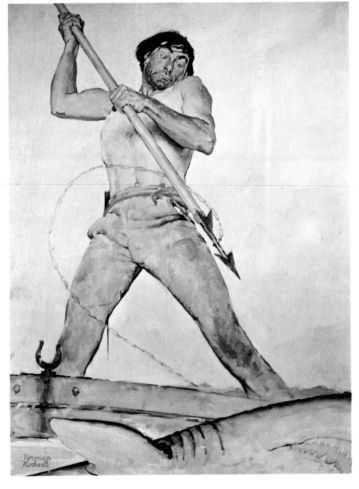

Harpooner.
1938. Original oil painting.
Collection Pete Martin

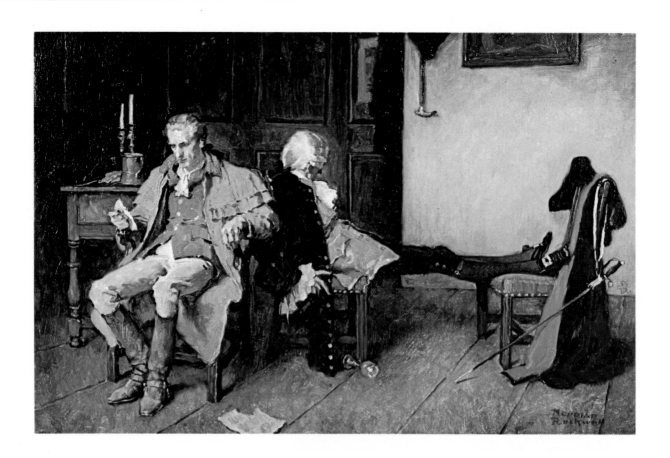

Whig and Tory. *1938. Original oil painting. Collection Pete Martin*

Airplane Trip.
Post *cover, June 4, 1938.*
Original oil painting,
Collection Mr. and Mrs. M. Kunstler

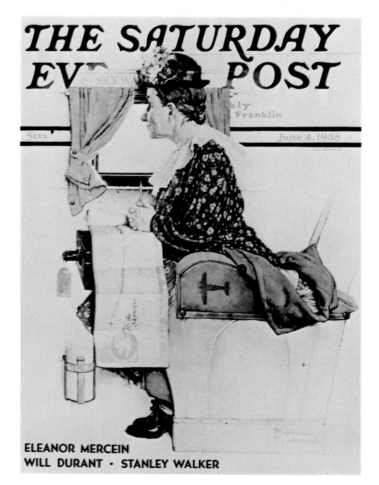

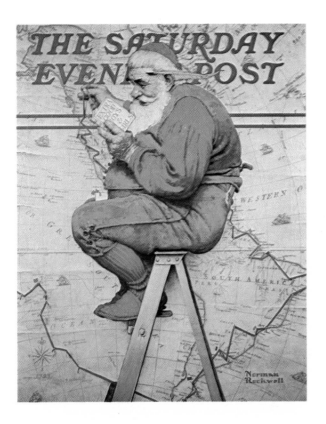

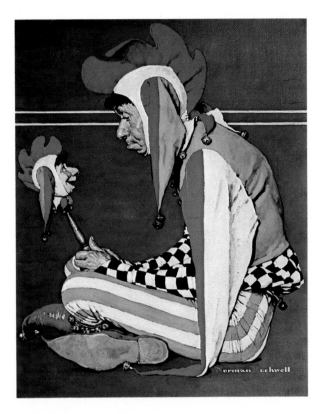

Extra Good Boys and Girls. *Original oil painting for* Post *cover, December 16, 1939. Collection A. Haigh Cundey*

Jester. *Original oil painting for* Post *cover, February 11, 1939. Collection Mrs. G. A. Godwin*

over the surface. If Rockwell found himself too dependent on his photographs at first, he got over it very quickly, and much of this work would be hard to beat for caricature, design, and graphic impact. It is not easy—perhaps it is impossible—to tell the difference between paintings from life and paintings from photographs.

Although he began as an illustrator, assignments for cover designs and commissions for advertisements left little time for less glamorous and less well-paid story illustration. The revival of his interest came in 1935 with the commission to do eight color paintings for a deluxe edition of *Tom Sawyer* and another eight for *Huckleberry Finn,* to be published by Heritage Press. The right job at the right time—twenty years of experience painting barefoot boys, the opportunity to join the grand tradition of illustrating classics, and a welcome change from thinking up his own stories. The results are remarkable. The paintings are free and spontaneous; each has an immediacy about it as if the viewer were there.

Between 1930 and 1939 Rockwell did sixty-seven covers for the *Post*—twenty-two less than he had the previous decade but considerably more than any other artist was doing. Only ten of these covers had children as the main subject. In general terms his approach be-

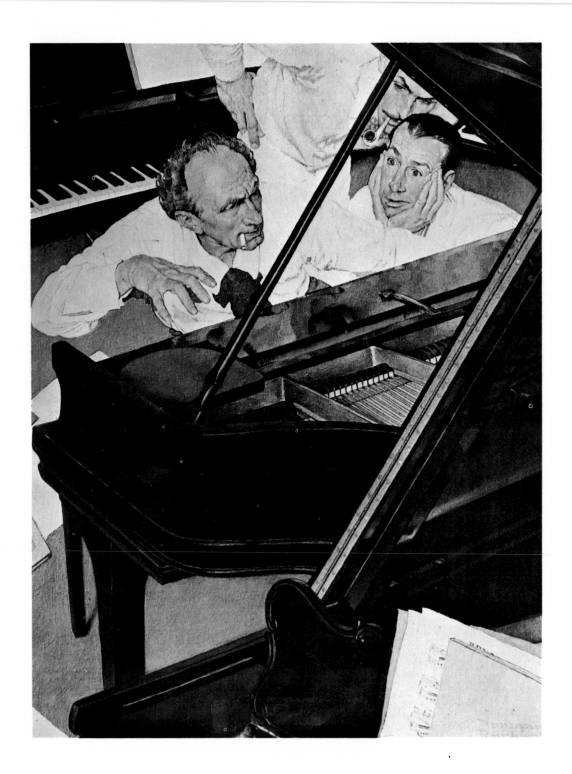

The Virtuoso. *Original oil painting for* Post *illustration, May 27, 1939.*
Collection Mr. and Mrs. Frank M. Rubinstein

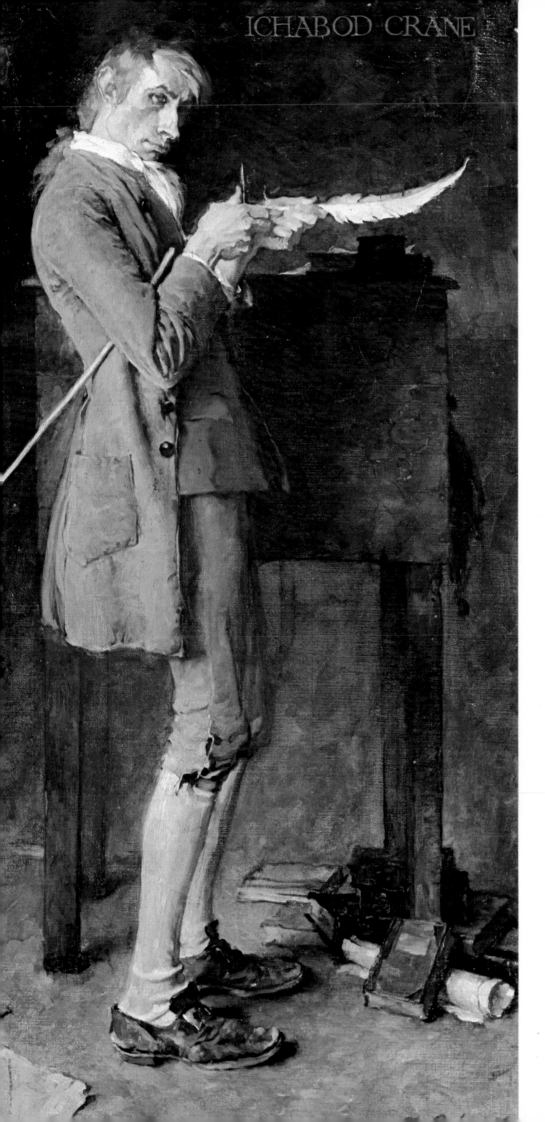

ICHABOD CRANE

Ichabod Crane. *Late 1930s.*
Original oil painting.
Collection Norman Rockwell

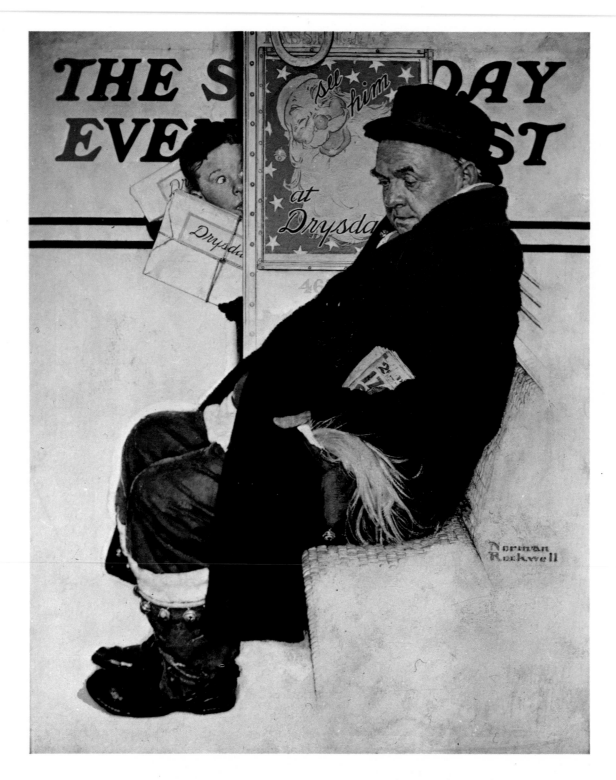

Santa on Train. *Original oil painting for* Post *cover, December 28, 1940. Collection Mr. and Mrs. Jack D. Emery*

THE HORSESHOE FORGING CONTEST ▶

Original oil painting for illustration to
"Blacksmith's Boy—Heel and Toe" by Edward W. O'Brien,
Post, *November 2, 1940. Collection Norman Rockwell*

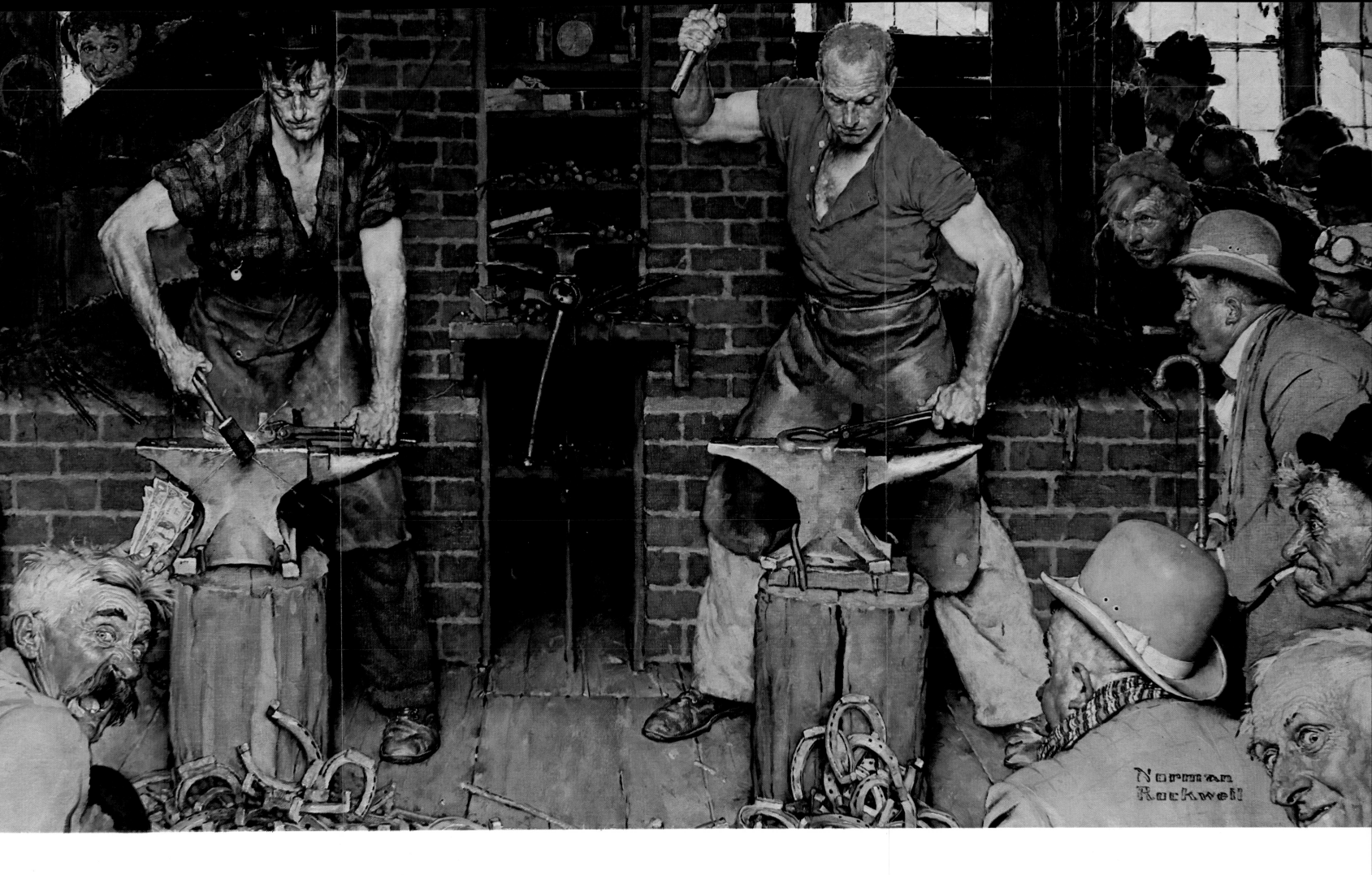

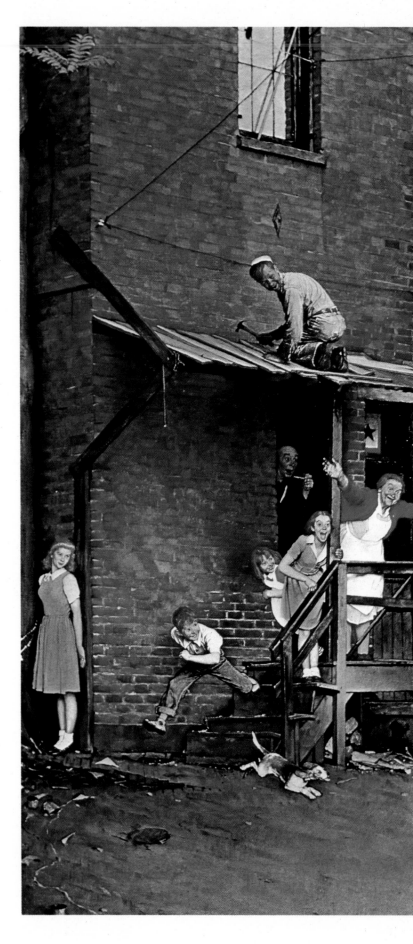

Homecoming G.I. *Original oil painting for* Post *cover, May 26, 194*

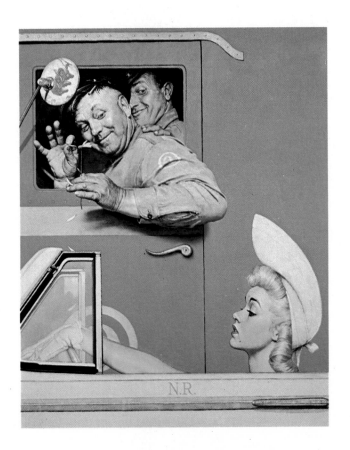

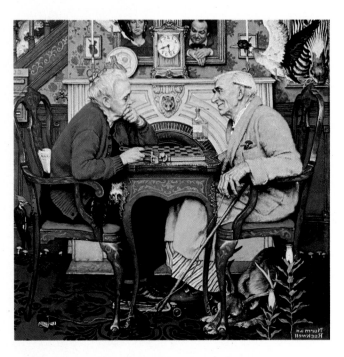

The Flirts. *Original oil painting for* Post *cover, July 26, 1941.* *Collection Harry N. Abrams, Inc., New York*

April Fools. *Original oil painting for* Post *cover,* *April 3, 1943. Collection J. and R. S. Schafler*

came less sentimental and the past was treated as decorative rather than nostalgic. More sophisticated subjects were introduced: horseback riding, antiquing, the theater. Sports—football, baseball, hunting, fishing, and croquet—became adult pastimes, and several covers reflect contemporary interest in movie stars, progressive education, rumble seats, and early Americana.

Rockwell took on World War II as if he had discovered it. Twenty-four years earlier he had pictured America's fighting men as Boy Scouts on bivouac—sewing on buttons, thinking of Mom, and singing "Over There." Now he saw soldiers and sailors as civilians in uniform—and the war itself as everybody's fight. He conceived the idea of explaining through pictures what the war was all about. The *Four Freedoms* were the result. Millions of copies were printed and distributed by the government and private agencies all over the world; the Treasury department toured the four originals to sixteen cities where they were seen by 1,222,000 people and used in selling $132,999,537 worth of war bonds. For many Americans World War II made sense because of the goals depicted in the *Four Freedoms*.

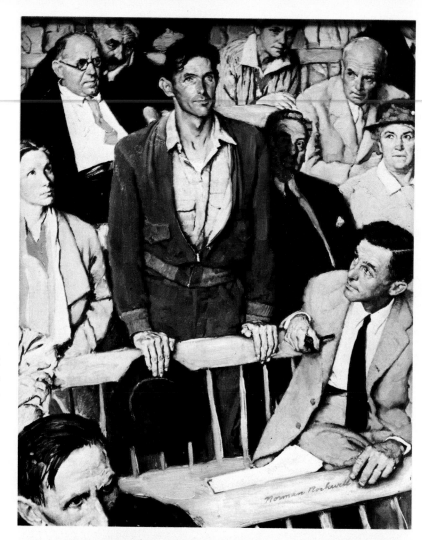

Freedom of Speech.
*Original oil painting
for poster, 1943.
The Metropolitan Museum of Art,
New York.
George A. Hearn Fund, 1952*

Freedom from Fear.
*Original oil painting
for poster, 1943.
Collection Norman Rockwell*

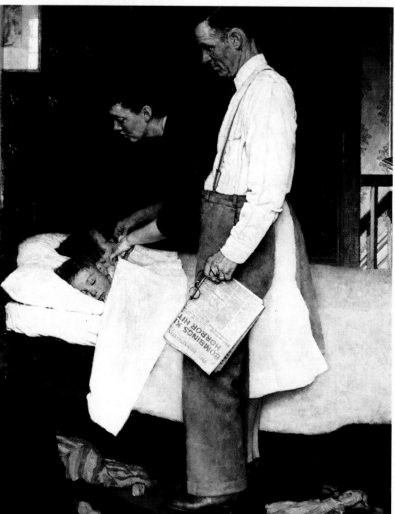

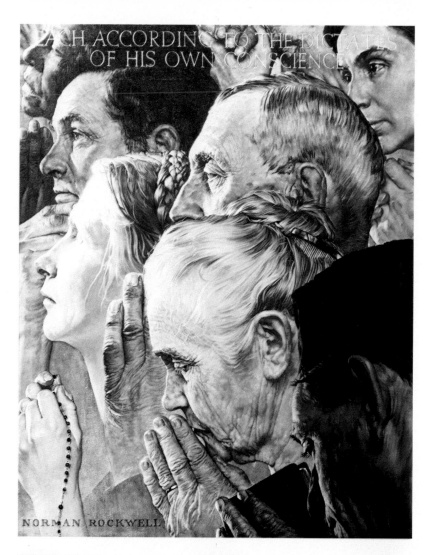

Freedom of Worship.
*Original oil painting
for poster, 1943.
Collection Norman Rockwell*

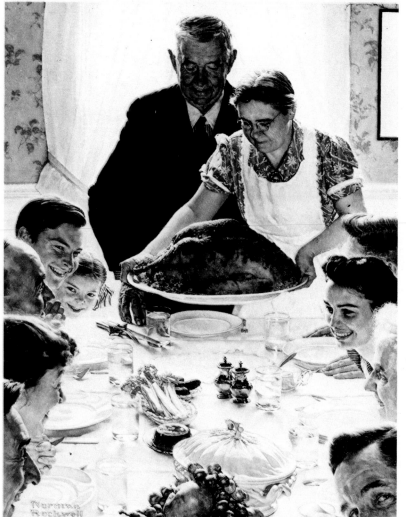

Freedom from Want.
*Original oil painting
for poster, 1943.
Collection Norman Rockwell*

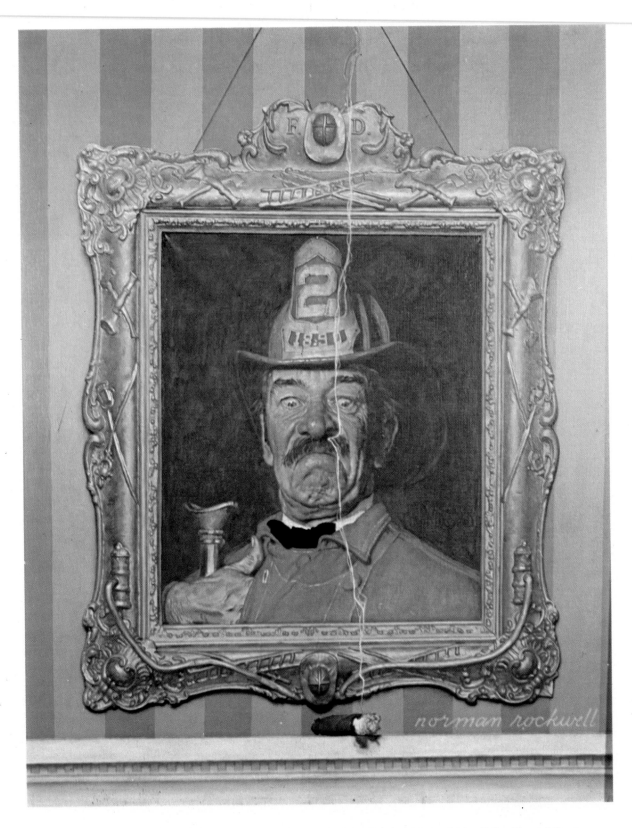

Fireman. *Original oil painting for* Post *cover, May 27, 1944. Collection Mr. and Mrs. J. Buckhout Johnston*

The Tattoo Artist. *Original oil painting for* Post *cover, March 4, 1944. The Brooklyn Museum* ▶

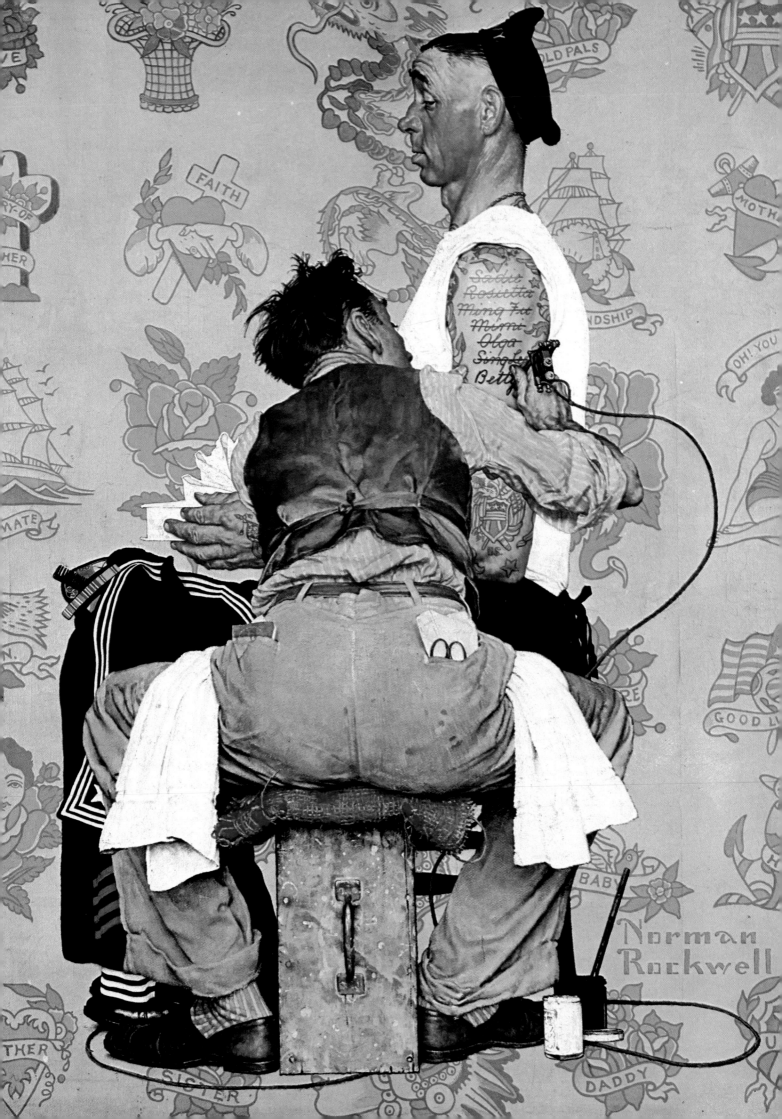

Willie Gillis.
Original oil painting for
Post *cover, September 16, 1944.*
Collection Mr. and Mrs. Ken Stuart

Saturday Evening Post *cover,*
October 4, 1941

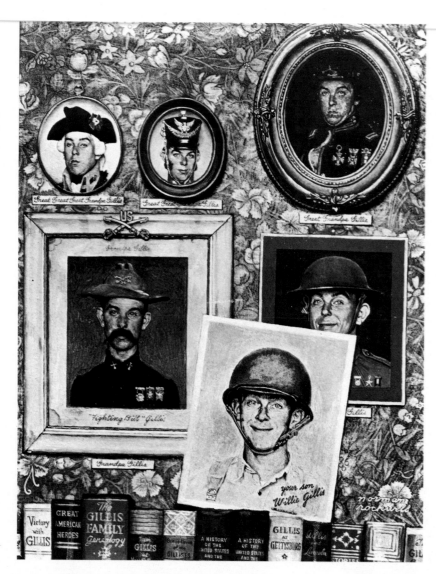

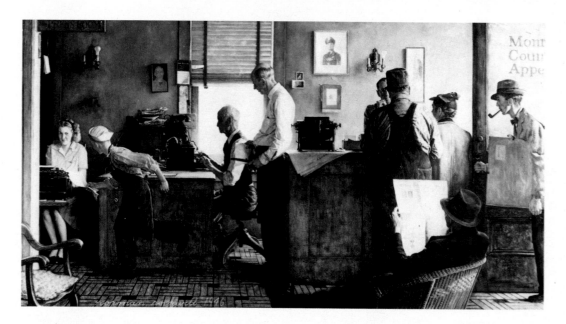

Norman Rockwell Visits a Country Editor. *Original oil painting for a double-page spread for the* Post,
May 25, 1946. Collection National Press Club, Washington, D.C.

For Rockwell, departure from reassuring entertainment had been made and was to be made many times thereafter.

Rockwell extended his fight through posters and calendars and ads. Time devoted so successfully to doing illustration in recent years was assigned to pictorial reporting, the nonfiction phase of storytelling. Photographer in tow and sketchbook in hand, Rockwell visited the President, rode a troop train, and stood before his ration board, all of which appeared within the *Saturday Evening Post*. The simplest measure of his involvement is that twenty-five of the thirty-three covers done during this period relate to the war; twenty-four years earlier only four out of eighteen did. G. I. Joe was one of Rockwell's great subjects; on the cover of the *Post* his homecoming was recorded seven times.

For the remainder of the decade, he continued the pictorial documentaries for the *Post*, began a four seasons calendar series for Brown & Bigelow (which still continues), and did his first Christmas cards for Hallmark. Perhaps as a reaction to the war and the realism he brought to it, the work for these new clients is irrepressibly benevolent caricature, still another facet of Rockwell's talent.

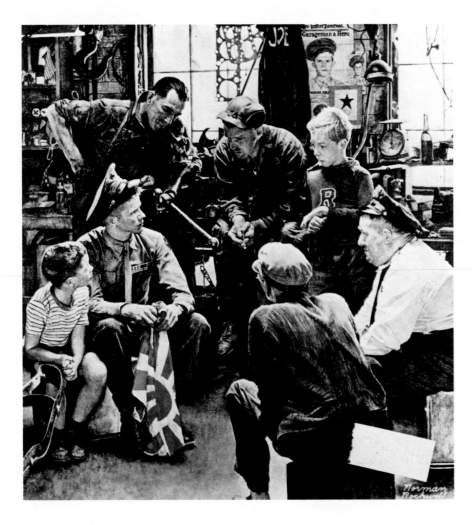

Homecoming Marine (The Storyteller).
Original oil painting for Post *cover,
October 13, 1945. Collection Harry Wohl*

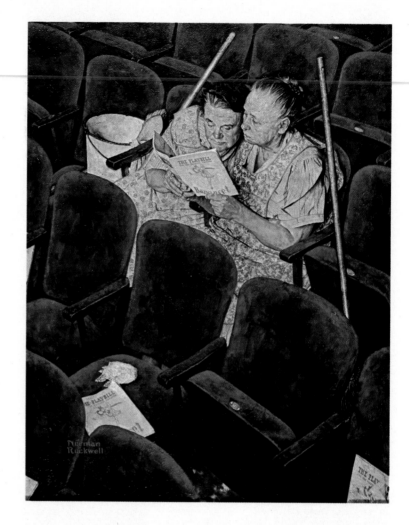

The Chars.
Original oil painting for
Post *cover, April 6, 1946.*
Collection Newell J. Ward, Jr.

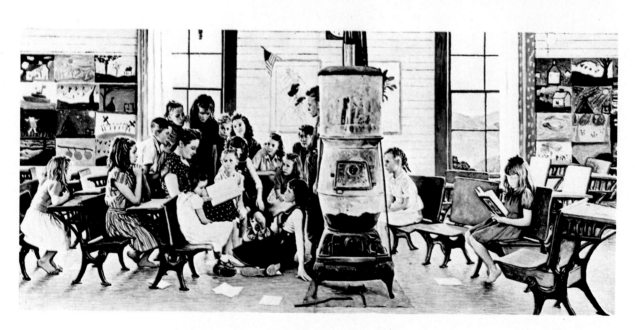

Red Oaks, Georgia Schoolroom. *Original oil painting for* Post, *November 2, 1946. Private collection*

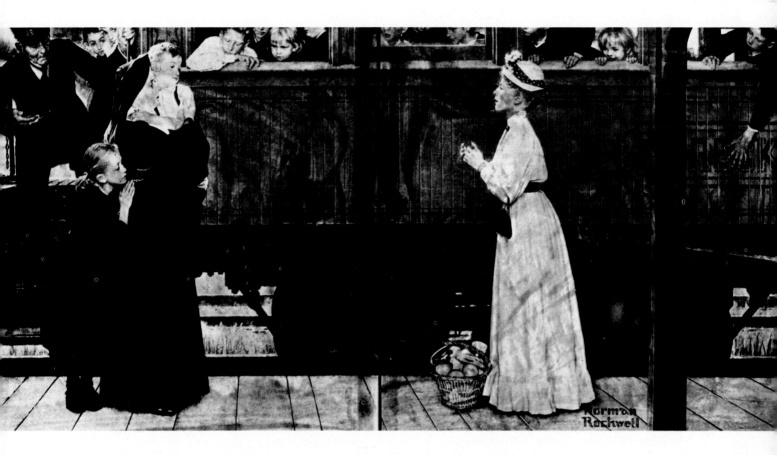

Little Orphan at the Train. *Late 1930s. Final oil painting for illustration from Rockwell's scrapbooks. Collection Mr. and Mrs. Peter Lind Hayes*

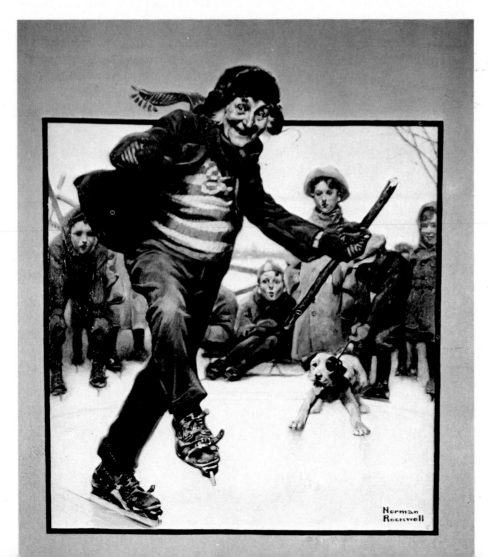

Skater. *1947.*
Original oil painting.
Collection Mr. and Mrs.
Howard Weingrow

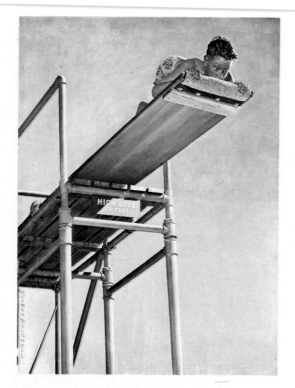

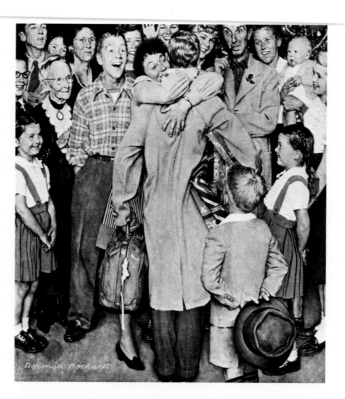

Young Boy on High Dive Board.
Original oil painting for Post *cover, August 16, 1947.*
Collection Mr. and Mrs. Robert S. Lubin

Homecoming. *Drawing for* Post *cover, December 25, 1948.*
Bernard Danenberg Galleries, Inc., New York

A personal and professional disaster occurred in 1943 just after the *Four Freedoms* were completed: Rockwell's studio near Arlington burned to the ground. From his point of view it was the loss of twenty-eight years of accumulated props, costumes, materials, and equipment—no more period pieces; from ours it was the loss of an unrecorded number of original paintings and his files of clippings. Today nobody including Rockwell himself has more than a vague idea of the extent of his work. There are no records.

Having "reported" the fire for the *Post* in a sheet of charcoal pencil drawings (July 17, 1943) Rockwell bought a house in the town of Arlington. Two other *Post* cover artists, Mead Schaeffer and John Atherton, lived there and the three became good friends, posing and providing criticism or moral support for each other upon request. Mead Schaeffer posed as the tattooist on the March 4, 1944, cover of the *Post*.

The trade press, beginning with *International Studio* in 1923, has always been interested in Rockwell. *Poster, American Artist, Design,* and *Graphic* have reproduced his work over the years. During the forties, *Arts, Art News,* and *Art Digest* also took notice, usually kindly but rarely enthusiastically. A one-man show at the Milwaukee Art Institute in 1941, a *New Yorker* profile in the March 17

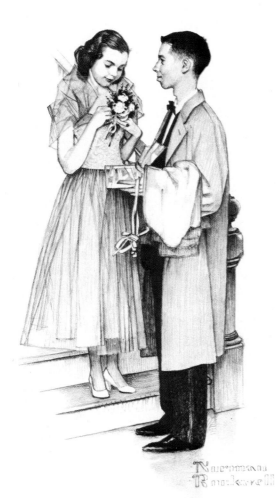

Advertisement for Massachusetts Mutual
Life Insurance Company

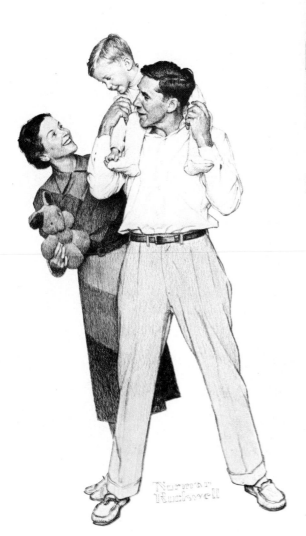

The Dugout. *Original oil painting for* Post *cover, September 4, 1948.*
The Brooklyn Museum

Advertisement for Massachusetts Mutual
Life Insurance Company

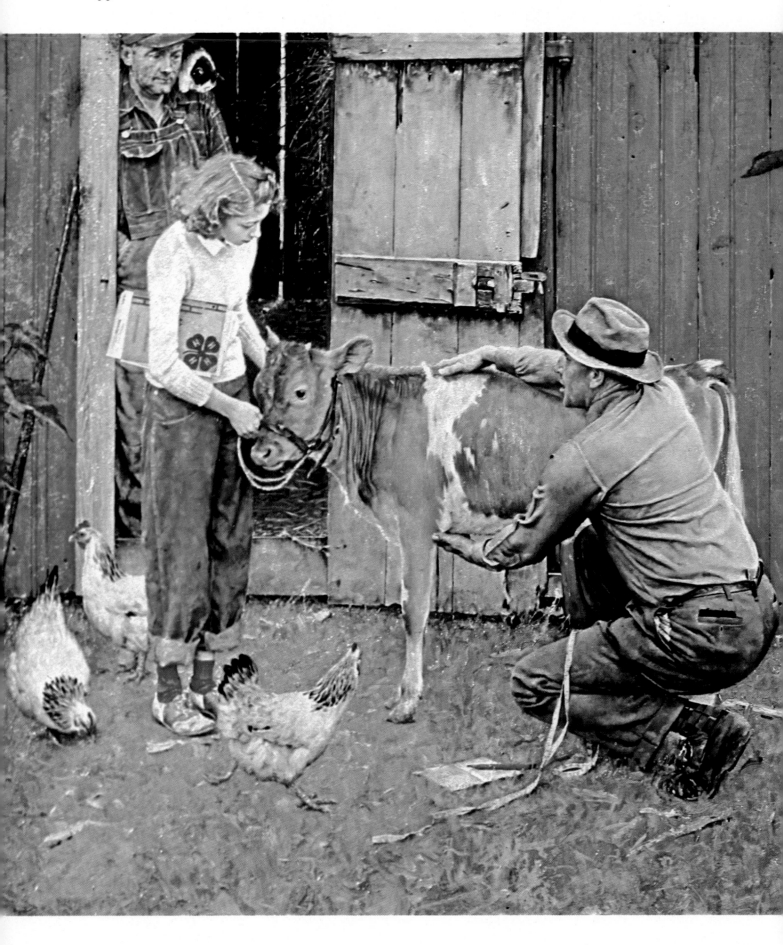

COUNTY AGRICULTURAL AGENT

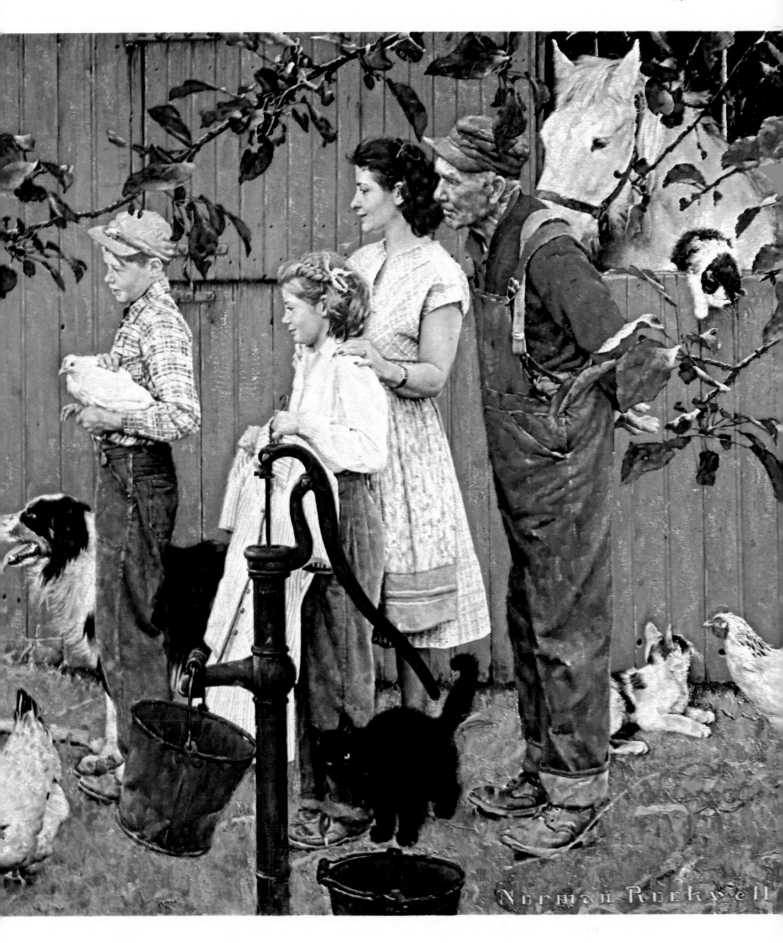

Original oil painting for Post, *July 24, 1948. Collection University of Nebraska Art Galleries, Lincoln. Gift of Nathan Gold*

and 24, 1945, issues, and Arthur Guptill's excellent monograph published in 1946 brought him before the most critical of art audiences where he was variously described as a fine artist, a folk artist, and no artist at all.

During this decade, photography seems to continue to present both problems and solutions. With his remarkable abilities in typecasting, arranging, and directing, he reaches new heights in authenticity and realism. His sense of subject often reverts to the *Literary Digest* era of action within a complete setting but with the difference that the setting is now sometimes as important as the actors themselves. In the old days with the model before him hour after hour, the physical relationship between artist and sitter was relatively constant—too far away and he could not see clearly, too close and he could not see the entire subject. Now with the camera recording the scene—totally or in parts—space could be treated in any number of ways, and was. The *Four Freedoms* are a case in point: although obviously intended to be seen together, each puts the viewer, who now stands where Rockwell's photographer stood, in a different relationship with the subject. He is two rows—four or five feet—from the Speaker, inches from the Religious People, at least ten feet from the Fearless Father, and, finally, sits in the midst of Plenty, right on the dining room table. Individually, these vantage points are most successfully used but when the pictures are hung in the same room (as they are in the Old Corner House in Stockbridge) they look as if they had been painted at different settings of a zoom lens.

A second problem inherent in the use of photographs is the artist's dependence on the surface appearance of his subject rather than on its underlying construction. This makes the lines derived from the photographs of great importance because they are the major source of information. Consequently, they cannot be obscured by layers of paint until the artist is absolutely sure of what he is doing. This has two visible effects: first, the painting looks thin and transparent and, second, where the paint is thicker, it piles up in little islands surrounded by valleys where the lines once were or still are. The hampered brushwork that sometimes results is not usually noticeable in reproduction.

On the positive side, this demanding process and the serious subjects to which it was applied produced, in reaction, a delightful freehand style, which may rely on photographs for poses but certainly not for people. Rockwell's natural ability to caricature has been evident on and off from the days when he did illustrations for *Boys' Life*. In some instances, the Nassau Tavern mural and *The Horseshoe Forging Contest*, for example, this ability comes into conflict with his love of authentic reality. The soldiers on the right side of the farmer

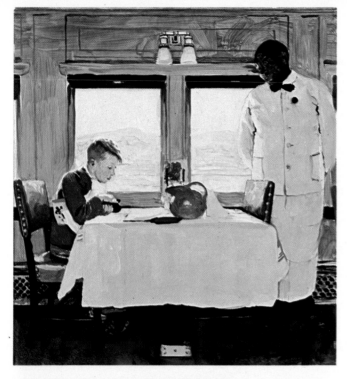

New York Central Diner.
Study for Post *cover, December 7, 1946.*
Collection Richard Rockwell

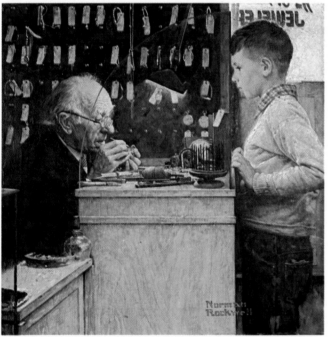

The Watchmaker.
Original oil painting for advertisement for
The Watchmakers of Switzerland, 1948.
New York and Bienne, Switzerland

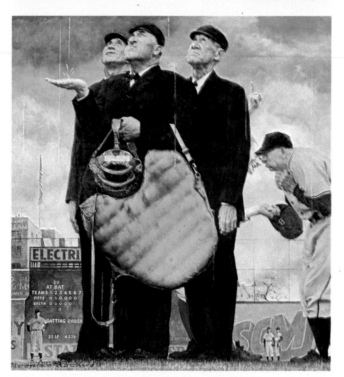

Game Called Because of Rain.
Original oil painting for Post *cover, April 23, 1949.*
National Baseball Hall of Fame
and Museum, Cooperstown, New York

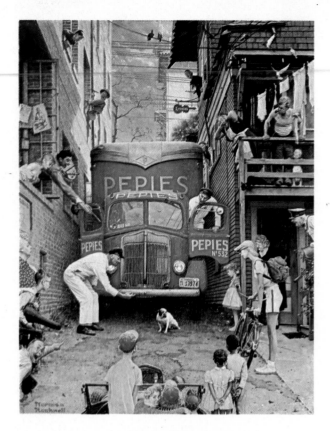

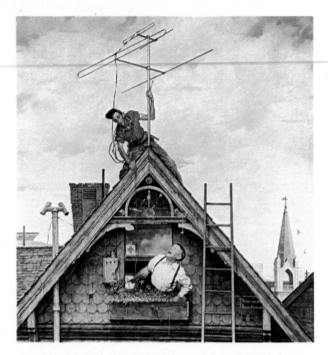

The New Television Set. *Original oil painting for* Post *cover, November 5, 1949. Los Angeles County Museum of Art. Gift of Mrs. Ned Crowell*

Traffic Conditions. *Original oil painting for* Post *cover, July 9, 1949. Collection Mr. and Mrs. Phil Grace*

are caricatures compared with the officer on the left; some of the people watching the blacksmiths are exaggerated; others are not. (As an aside on Rockwell's horizontal pictures, they tend to be divisible into two equal halves with composition or action attracting the viewer's attention to the left half.)

Rockwell's treatment of the *Post* cover space from 1940 to 1949 reflected the camera's flexibility and also the new lettering design adopted at the end of June, 1942. Having grown accustomed to going behind or in front of the type that filled the upper fifth of the space, he now appeared under or around it. The name of the magazine had gradually become incidental to the artwork; now it competed for the viewer's attention—and often won. After 1946, lettering describing special features within the magazine was confined within the title panel at the top; no longer does copy cover up parts of the picture.

In addition to the war, the only obviously new subjects were some April Fool covers—fascinating in their juxtaposition of absolute realism and impossible nonsense. The forties treatment of such venerable themes as Santa Claus suggests a certain disillusionment with his own Panglossian vision: The Giver of Good Things slouches in the subway, his beard in his pocket. In using photographs and in accepting the world a little more as it sadly is, Rockwell found and mastered a new subject area: architectural exteriors. The returning soldier's tenement is a good example.

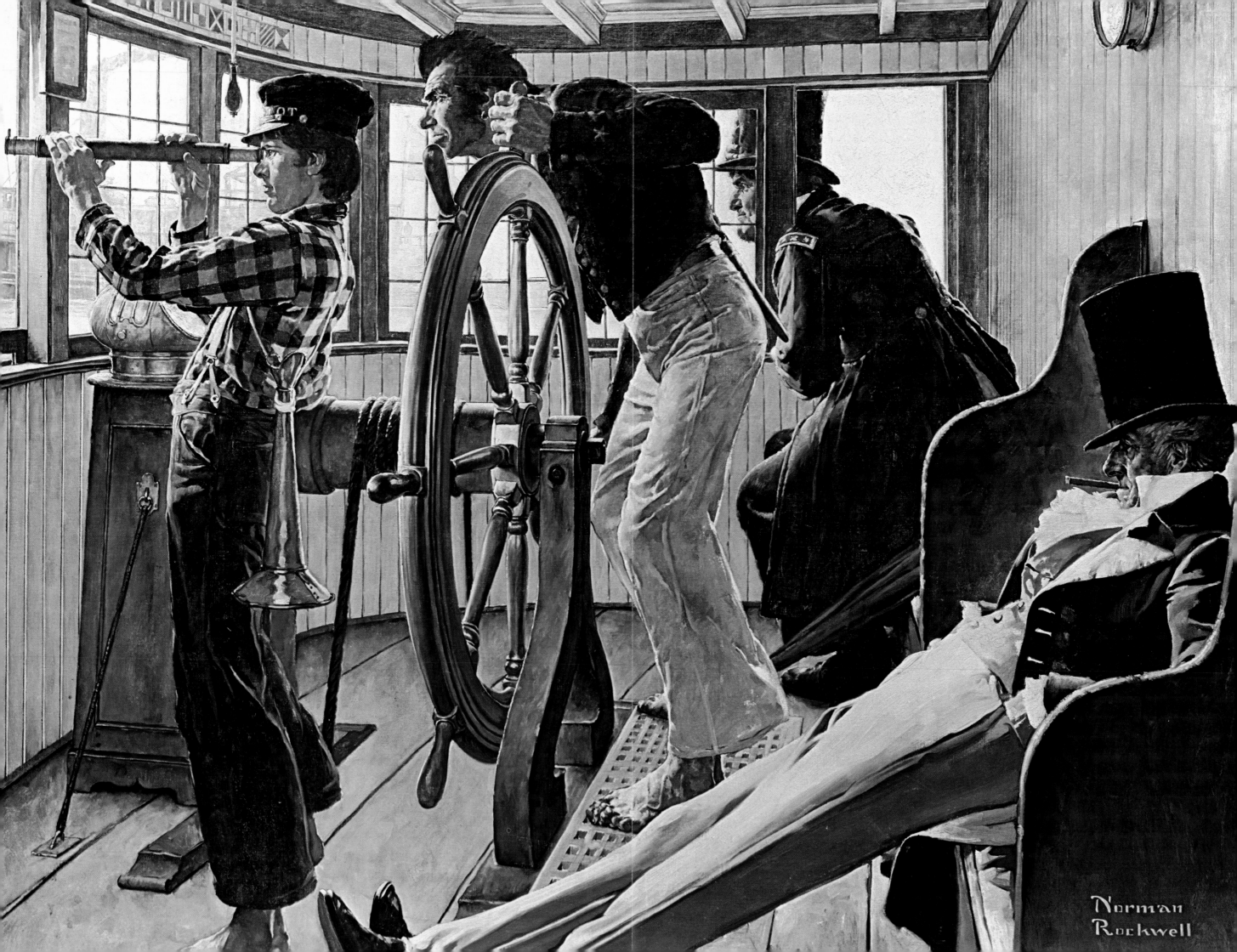

◀ STEAMBOAT RACE

1930s. Original oil painting.
Whereabouts unknown

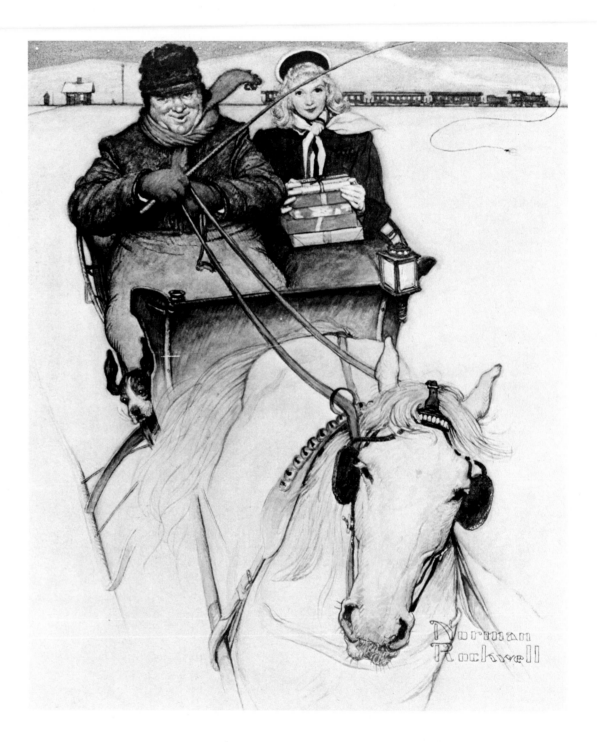

Hallmark Christmas card, 1949

1950 - 1971

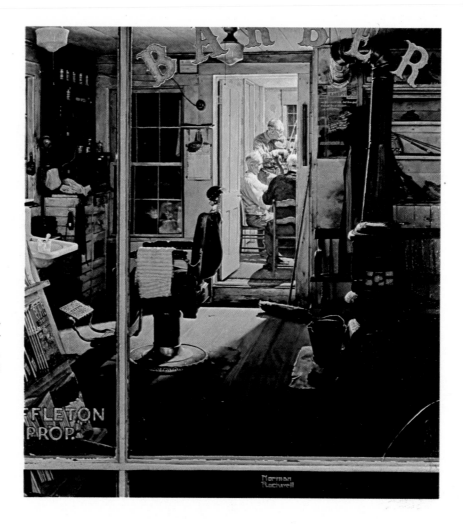

Shuffleton's Barber Shop.
Original oil painting for
Post *cover, April 29, 1950.*
Collection Norman Rockwell

IN 1951, ROCKWELL PAINTED THE MOST POPULAR OF ALL HIS *Post* COVERS—the grandmother and grandson saying grace in the railroad station restaurant. In 1952, he painted President Eisenhower, and he has painted every presidential candidate in every election since. But the decade began badly. The discouragement, uncertainty, and dissatisfaction that drove him to Europe in 1932 returned to accompany him through his move in 1953 from Arlington to Stockbridge, Massachusetts; he managed to go on meeting the endless barrage of deadlines with which he has always lived. He also managed to paint two of his best pictures: *Breaking Home Ties,* 1954, and *Marriage License,* 1955. In 1959, his wife Mary died, and he was alone again.

It is impossible to know how, or even if, these troubles affected his work. Changes certainly occurred. The most important one is a turning back to the subject of youth, to the subjects of his youth—boys, dogs, swimming, girls, adolescence, going to church, to the doctor's, to school.

Of the forty-one *Post* covers illustrated during the decade,

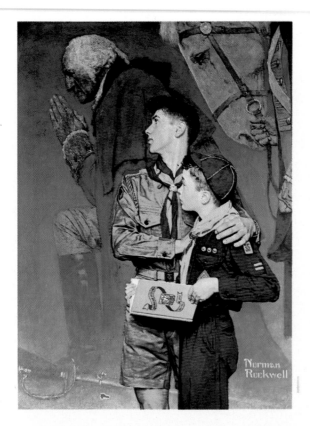

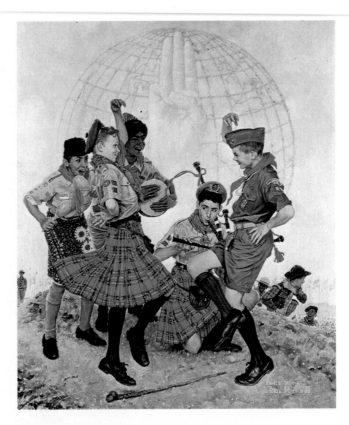

Our Heritage. *Original oil painting for Boy Scout calendar, 1950. Collection National Office, Boy Scouts of America, North Brunswick, New Jersey*

A Good Turn All Over the World. *Original oil painting for Boy Scout calendar, 1963. Collection National Office, Boy Scouts of America, North Brunswick, New Jersey*

twenty-two include children—as high a proportion as in the twenties.

These subjects of youth are based on situations typical of his early work but many now appear in new settings with new props—the hypodermic needle instead of the tongue depressor, the veterinarian's office instead of the patent medicine bottle. Although the cards and calendars generally minimize the setting while the *Post* covers emphasize it, a strong tendency, perhaps a compulsion, to caricature unites them stylistically. This can be both an asset and a liability. It can produce charming, lively, properly sentimental calendars—and it can ruin a good picture.

A great many commissions for advertisements were completed during this period. Rockwell did pencil drawings for the Massachusetts Mutual Life Insurance Company for twelve years starting in the early fifties. They describe pleasant, typical moments and milestones in the everyday life of a very Rockwellian family—without a trace of caricature. The same straightforward realism is characteristic of ads for Crest toothpaste, Parker pens, and American Telephone and Telegraph. The creative aspect of all of these illustrations

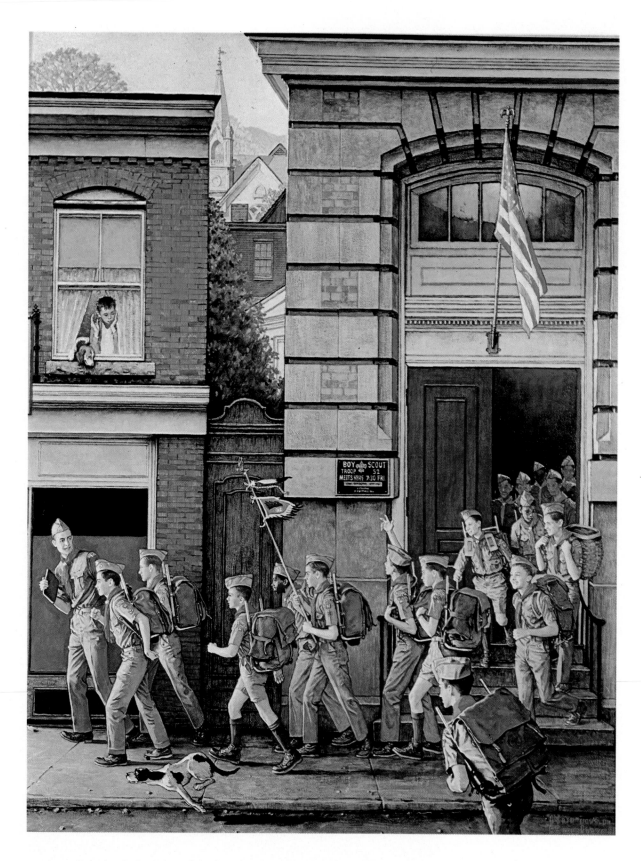

Scouting is Outing. *Original oil painting for Boy Scout calendar, 1968. Collection National Office,*
Boy Scouts of America, North Brunswick, New Jersey

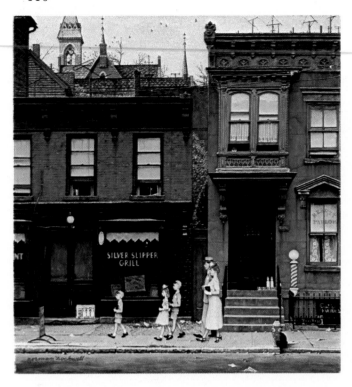

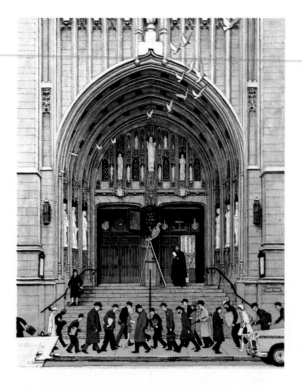

Walking to Church. *Original oil painting for* Post *cover, April 4, 1953. Collection Mr. and Mrs. Ken Stuart*

Lift Up Thine Eyes. *Original oil painting for illustration appearing in* McCall's, *March, 1969. Collection Mr. and Mrs. Phil Grace*

Easter Morning.
Original oil painting for Post *cover, May 16, 1959. Private collection*

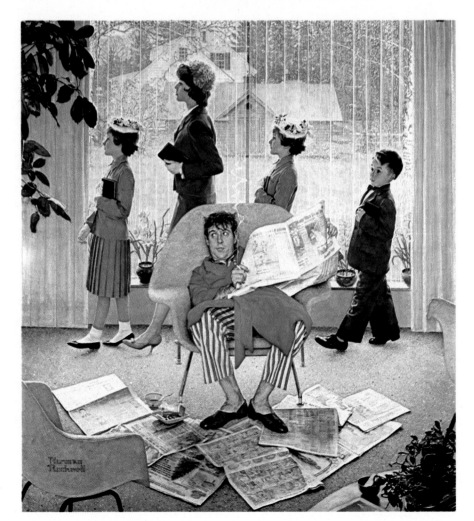

Triple Self-Portrait. *Original oil painting for* Post *cover, February 13, 1960. Collection Norman Rockwell* ▶

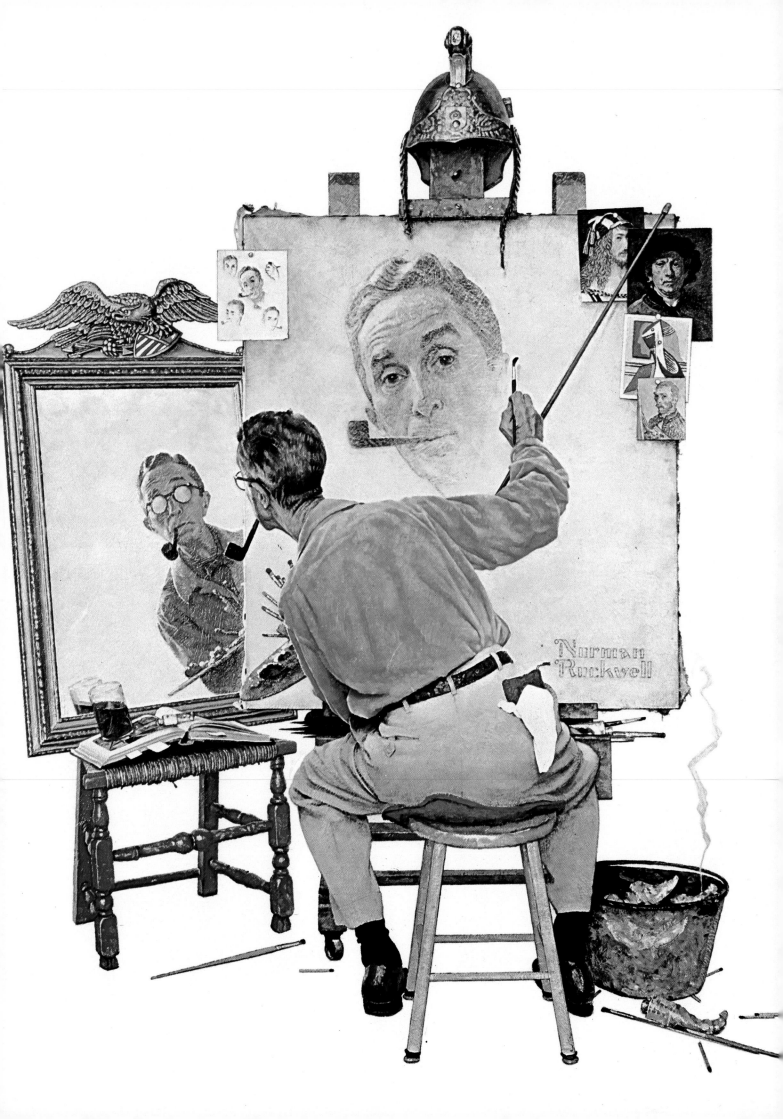

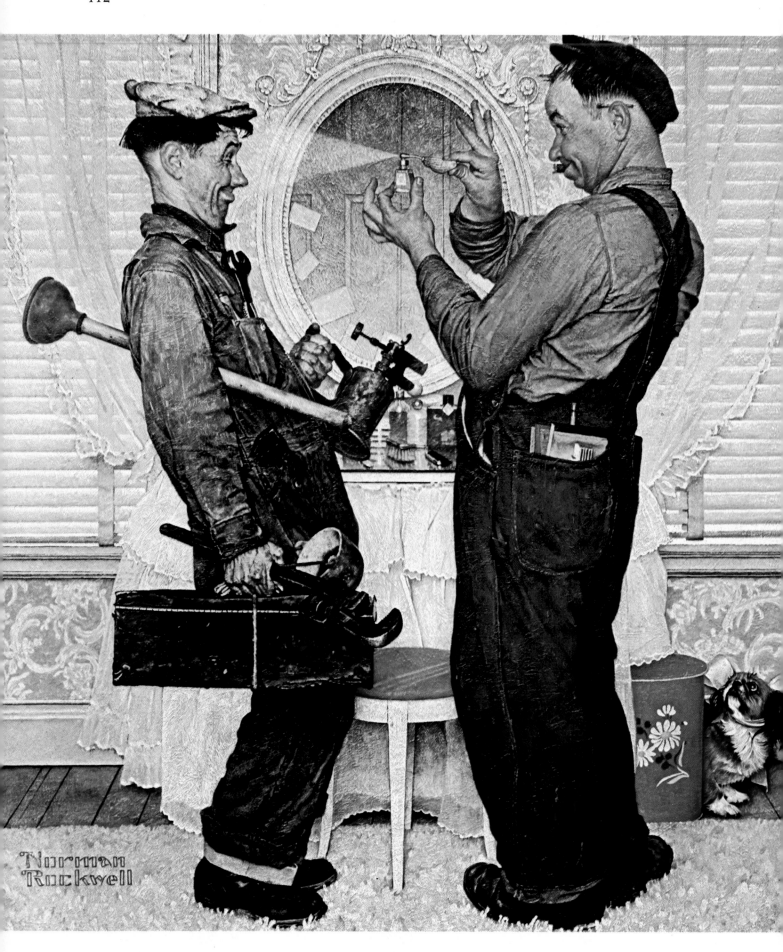

Two Plumbers and a Dog. *Original oil painting for* Post *cover, June 2, 1951. Collection Gordon Andrew*

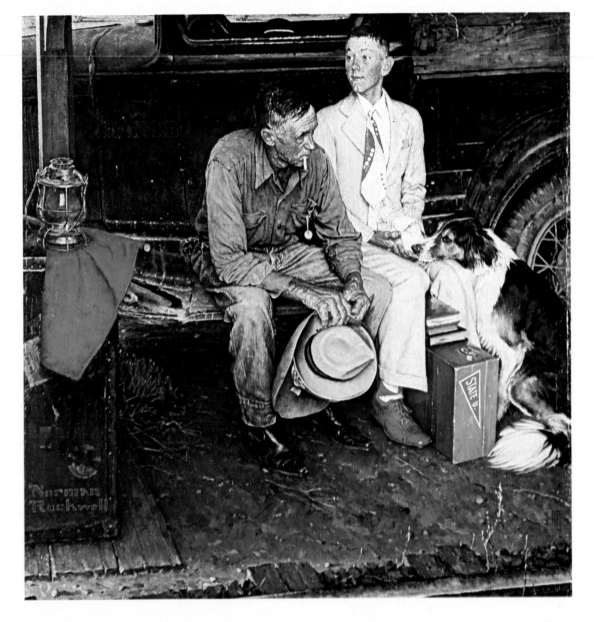

Breaking Home Ties. *Original oil painting for* Post *cover, September 25, 1954. Collection Don Trachte*

seems to lie more in Rockwell's ability to select, arrange, and direct his subjects than in his abilities as a painter. A series of four cards painted for Hallmark and the sketches done for Pan American World Airways, both in 1957, are exceptions. Although as realistic as everything else, they are painted in a fresh, loose style, quite unlike anything that has come before. Just as Rockwell had blossomed forth with a new approach to illustration after his first session with the doldrums in the late fifties, he came to life again with a new appreciation of the spontaneous.

In knowing only part of his work, it is easy to mistake continuing interest in certain subject themes for a revival of interest. Until everything Rockwell ever did is properly fed into a data bank and a computer is programmed to distinguish all sorts of subtle changes, no one can be sure. Our only certainty is that he always works very

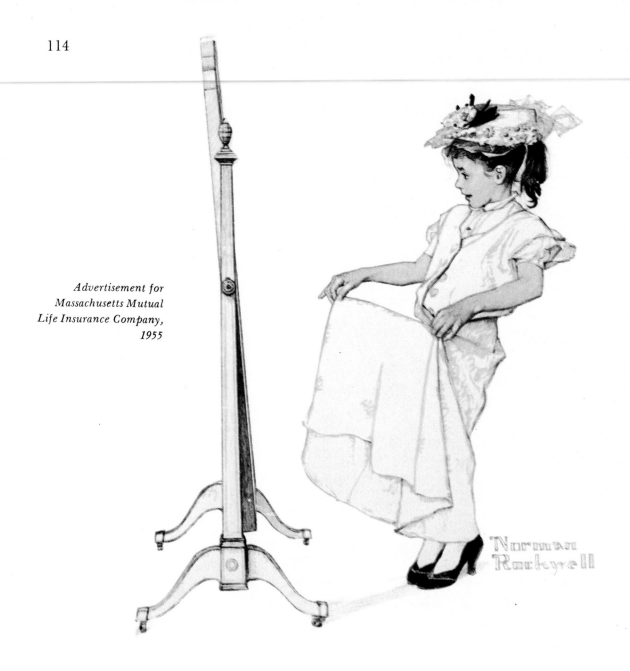

hard, produces a prodigious amount, and can keep several approaches to the same subject going simultaneously. His fascination with the dimension of time seems to be one consistent factor. Although he records precise moments, he wants the viewer to know what has just happened or will happen next.

Norman Rockwell's world was changing. The old swimming hole had become polluted, carefree youth came in two colors, and typical, average, ideal Americans were going to fly to the moon. In 1963, he left the *Saturday Evening Post* after an uninterrupted association of forty-seven years and went to work for *Look*. There was a big difference. Instead of painting cheerleaders he painted integration; instead of peace and prosperity, he painted poverty, protest, and the Peace Corps.

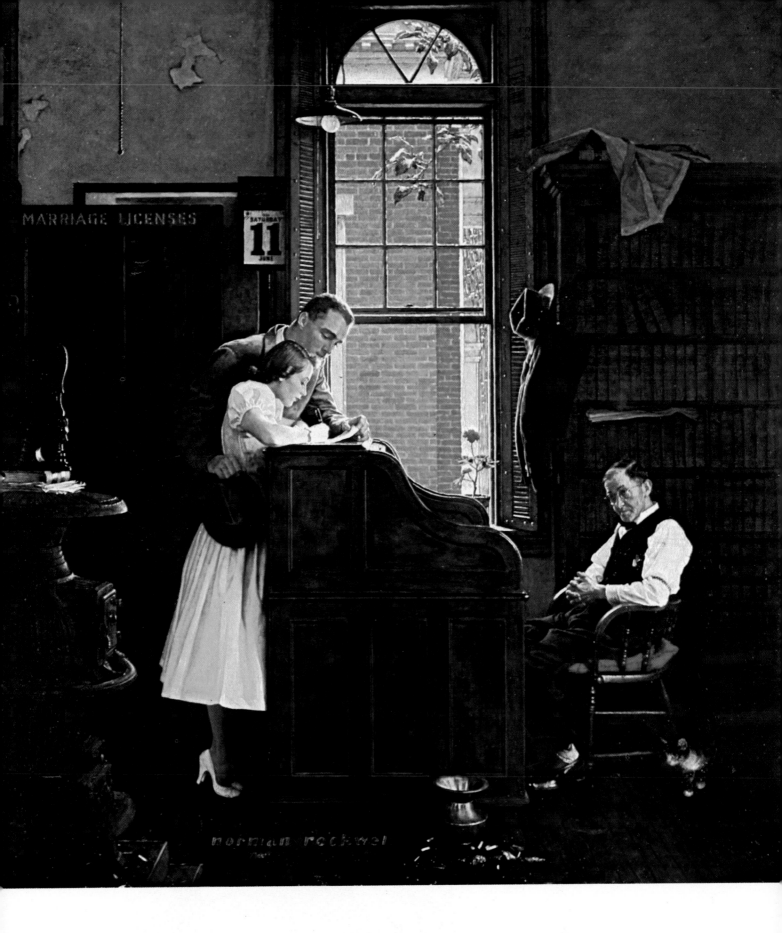

Marriage License. *Original oil painting for Post cover, June 11, 1955. Collection Norman Rockwell*

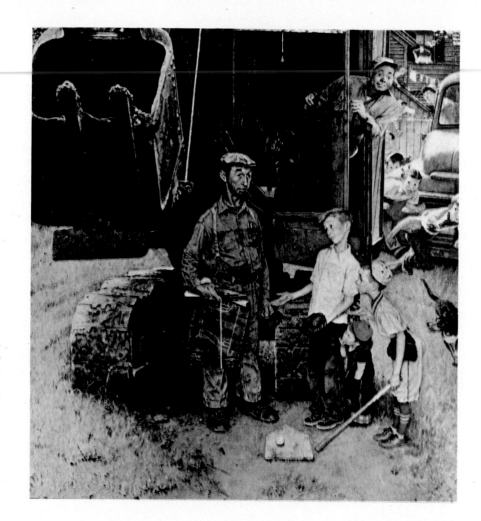

Construction Crew.
Original oil painting for
Post *cover, August 21, 1954.*
Collection Saturday Evening Post

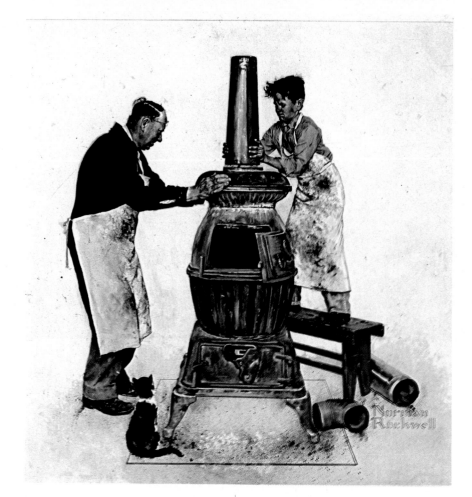

Preparing for Winter.
Original oil painting for
Four Seasons calendar, 1960.
Saks Galleries, Denver, Colorado

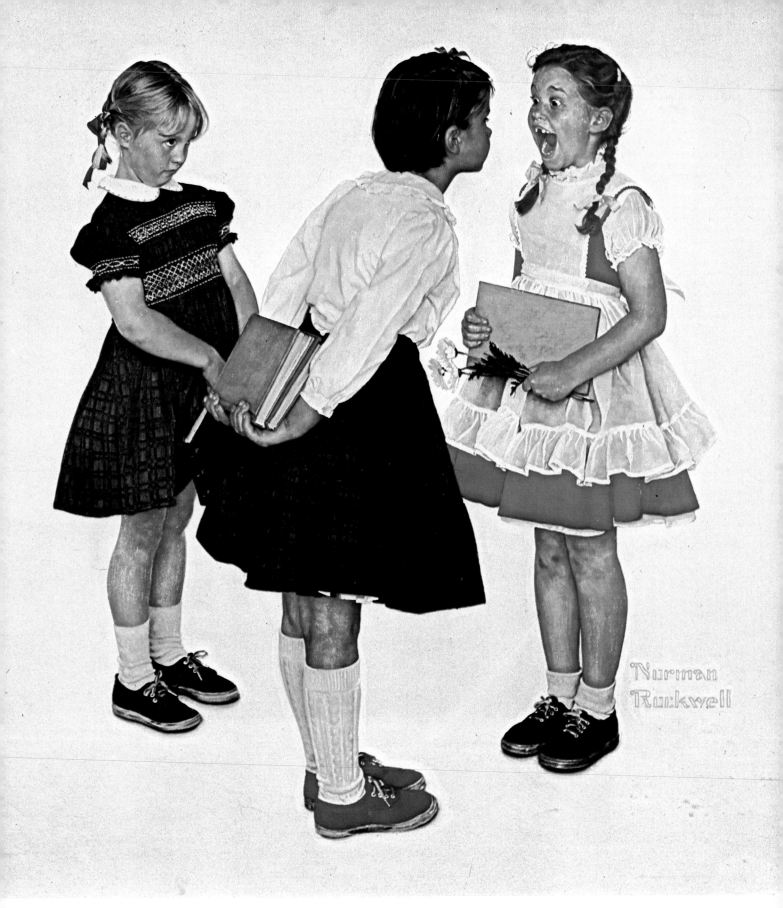

Checkup. *Original oil painting for* Post *cover, September 7, 1957. Private collection*

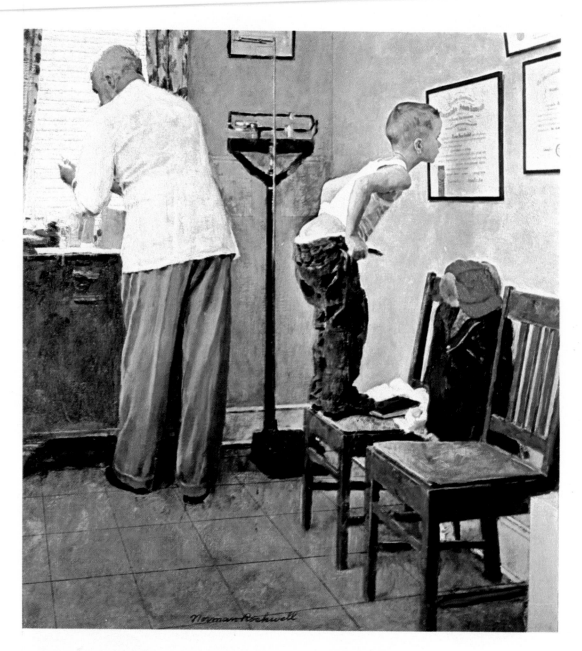

Before the Shot. *Original oil painting for* Post *cover, March 15, 1958.*
Collection Dr. and Mrs. Edward F. Babbott

What happened? How does a chronicler of nostalgic America turn into a crusader? How can a man spend half a century finding humor and pathos in the daily trivia of American life and suddenly start painting about Russian education, Ethiopian agriculture, and the space program? And how does a man who has prospered by avoiding controversy find himself in Little Rock?

Rockwell is a professional. He accepts assignments, does the work, and gets paid. He and the *Post* worshiped each other; they welcomed his cover ideas almost until the very end—but always subject to editorial approval. The point of view was the magazine's, not

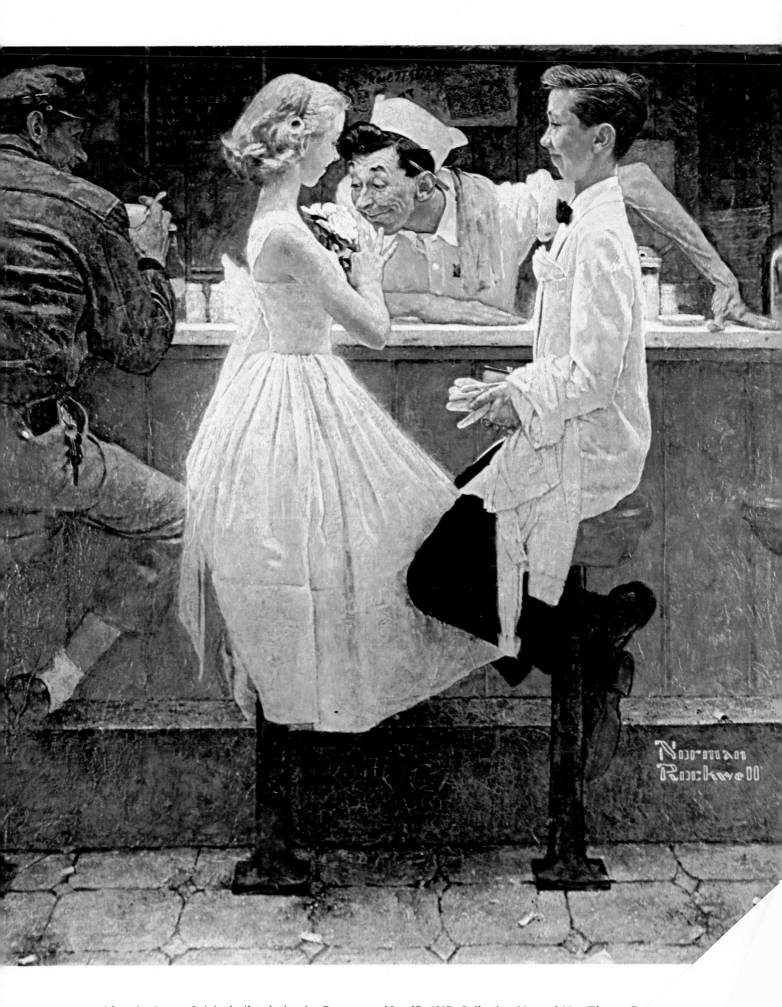

After the Prom. *Original oil painting for* Post *cover, May 27, 1957. Collection Mr. and Mrs. Thomas Ro*

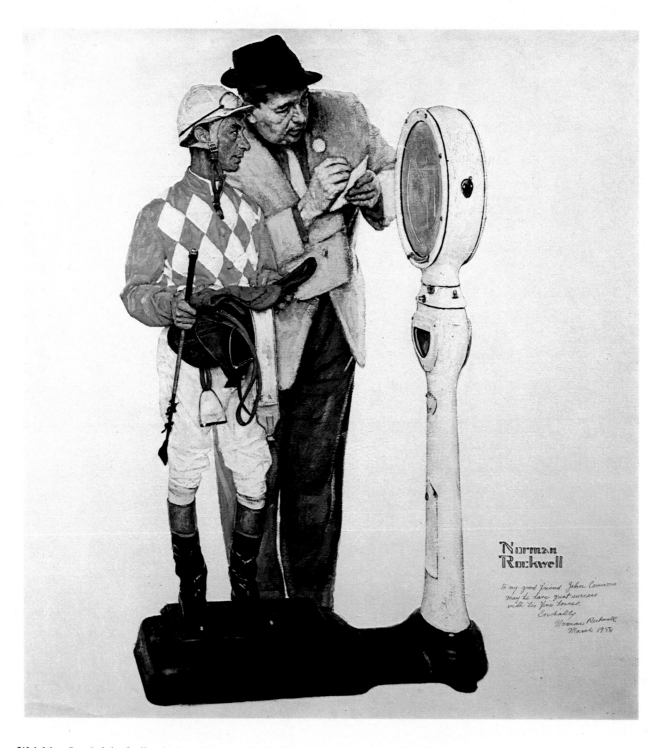

Weighing In. *Original oil painting of first version of* Post *cover, June 28, 1958. Collection Harry N. Abrams, Inc., New York*

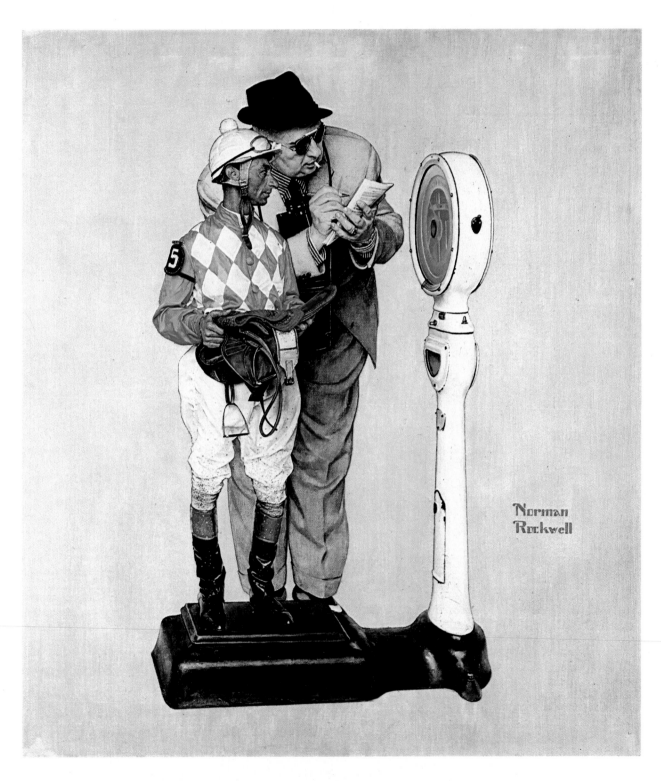

Weighing In. *Original oil painting of final version of* Post *cover, June 28, 1958. The New Britain Museum of American Art, Connecticut. Sanford Low Memorial Collection of American Illustration*

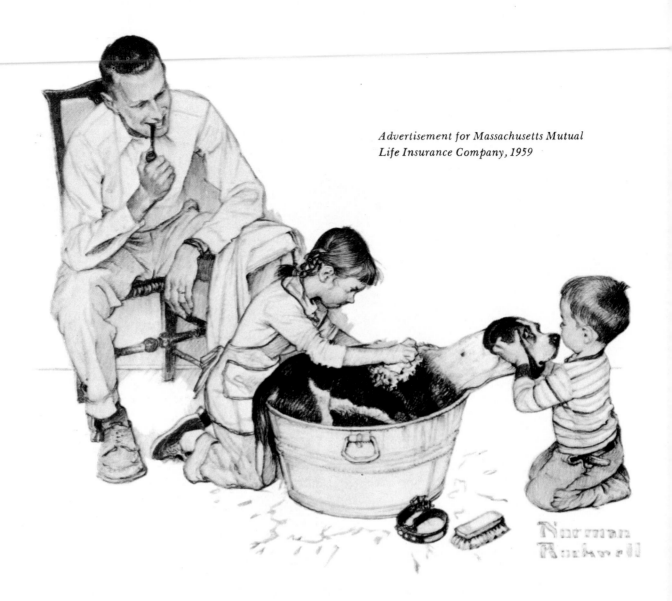

the artist's. Fortunately, Rockwell shared their point of view most of the time. But no job was done, no painting completed regardless of how strongly he wanted to do it, without their approval, including the *Four Freedoms*.

The *Look* jobs were almost completely special assignments. Rockwell accepted them, did the work, and got paid. The surprising and wonderful elements here are that the jobs were offered and that he did accept them. Imagine approaching the best-known artist in the country, a wealthy, venerable figure sixty-nine years old, and suggesting he change his line! And think of the artist who had just written in his autobiography: "I do ordinary people in everyday situations and that's about all I can do." But even the tenderest moment in the family albums is meager fare compared with a single footprint on the moon. No artist—even Pyle—has had such history to record.

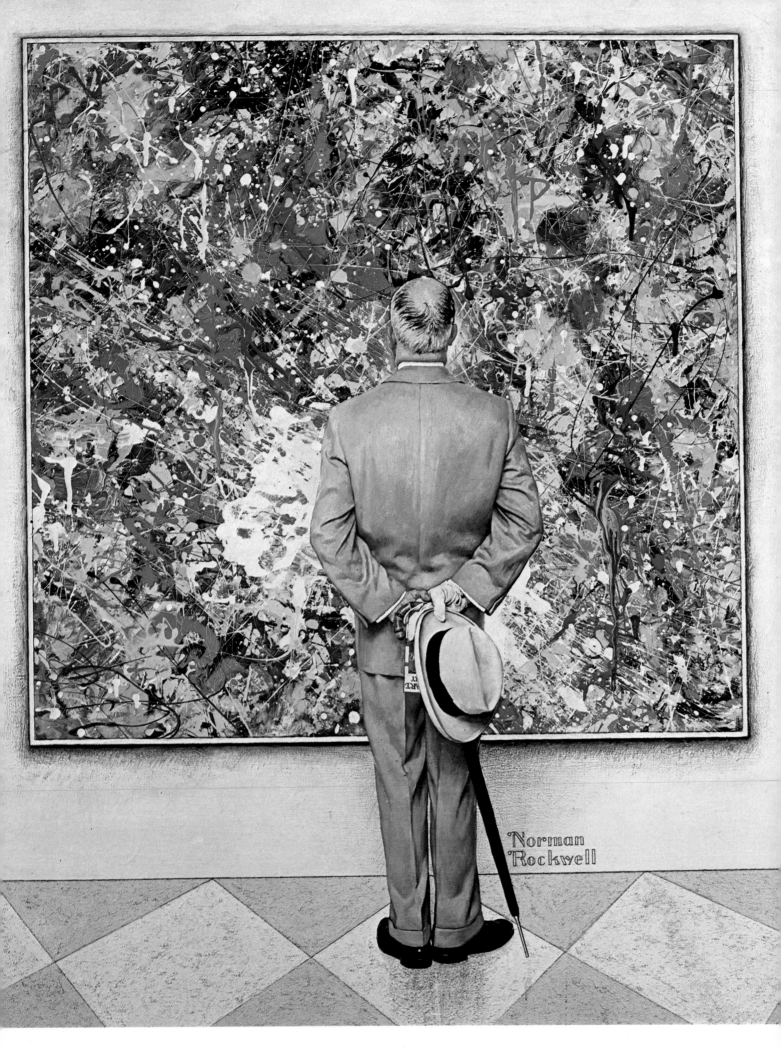

Abstract and Concrete. *Original oil painting for* Post *cover, January 13, 1962. Private collection*

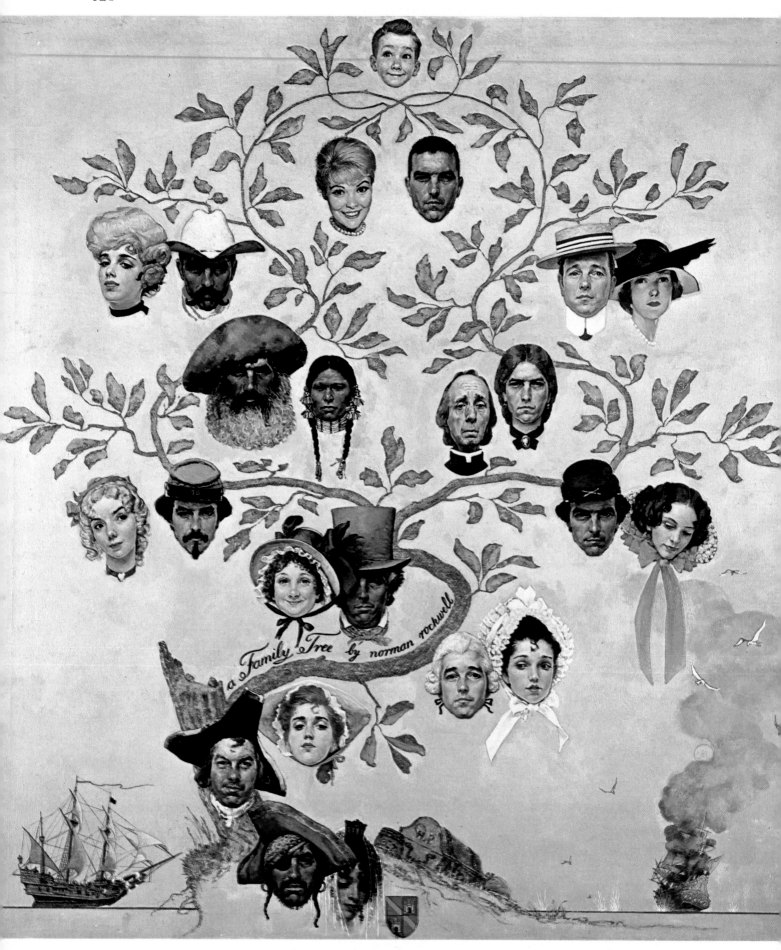

A Family Tree. *Original oil painting for* Post *cover, October 24, 1959. Collection Norman Rockwell*

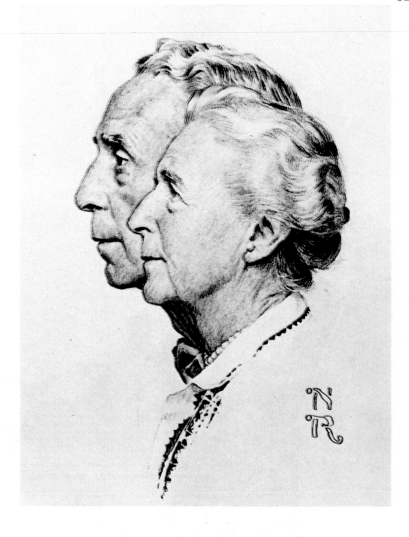

Rockwell and his wife Molly.
1967. Charcoal sketch.
Collection Norman Rockwell

The decade of the sixties began auspiciously: Rockwell painted *The Golden Rule* in 1960 and married Molly Punderson in 1961. All of the styles and subject themes—even period settings—that developed over the years turn up again: unfinished and partly finished sketches in pencil and paint, silhouetted groups, full interiors, caricatures and portraits, masses of people, exteriors—and, through it all, Boy Scouts. Rockwell's reuse of his own creations occurs surprisingly seldom considering the frequency with which he repeats themes and the length of time he has been working. The fact that he does so at all points up the work involved in creating a single vignette. Once done, it is a tangible property that can save hours of time if applicable to another subject or picture.

The massing of people—usually head-on or in profile—began with the *Freedom of Worship* in 1942, was used in several Boy Scout calendars, and became a major device in the sixties; *The Golden Rule, The Peace Corps in Ethiopia, How Goes the War on Poverty?, The Right to Know,* and *Man's First Step on the Moon* all got this treatment. Based on a studio-arranged composition made from pho-

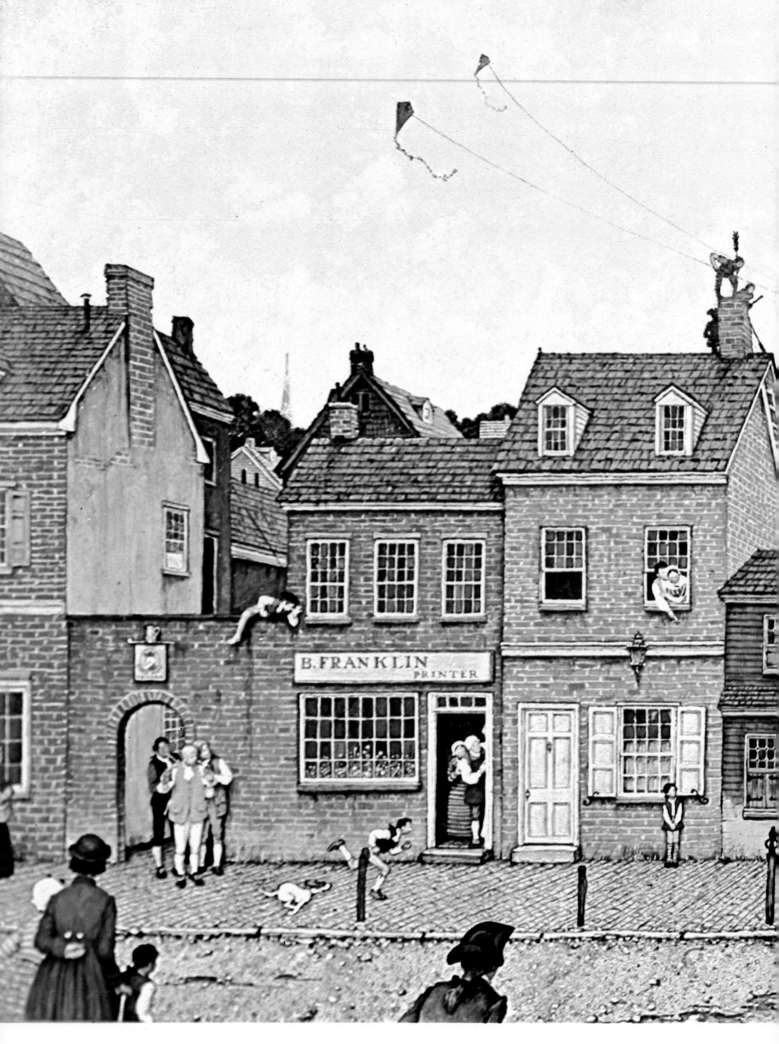

COLONIAL PHILADELPHIA

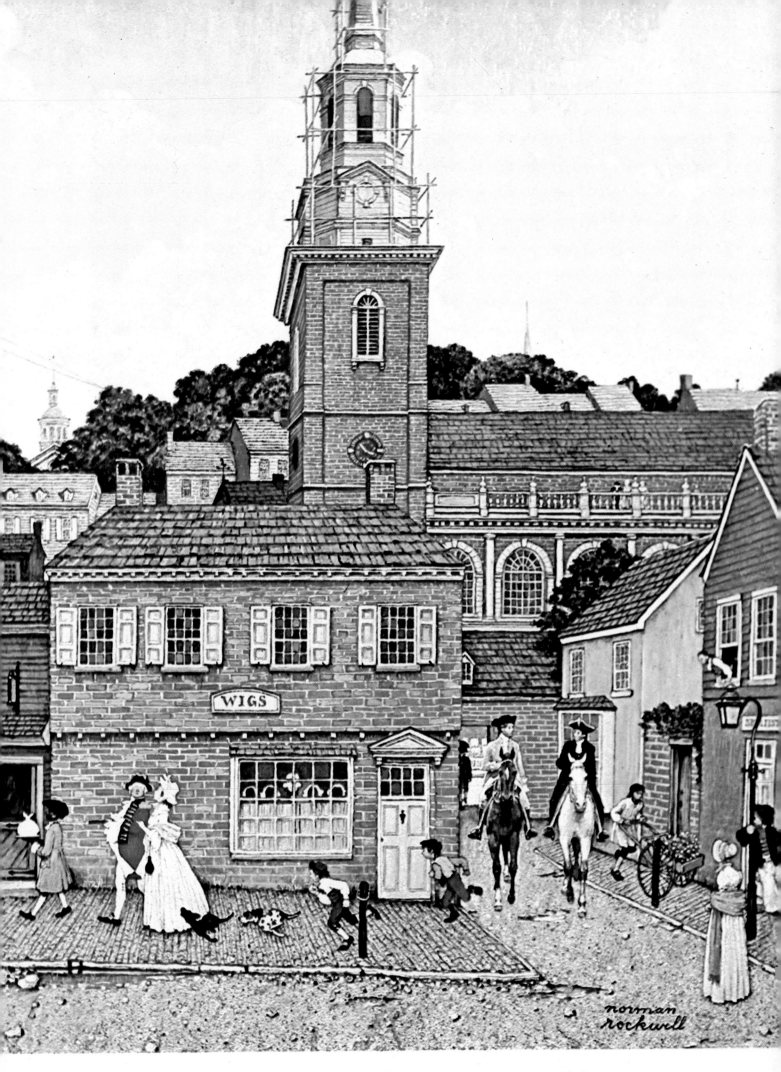

Original oil painting for illustration to Poor Richard's Almanacks, *1963. Collection Mrs. Victor H. Neirinckx*

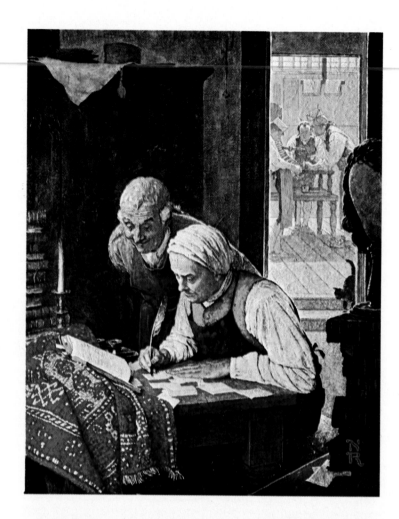

Ben Franklin at a Desk.
*Original oil painting for illustration
to* Poor Richard's Almanacks, *1963.
Collection Mr. and Mrs. Joseph H. Hennage*

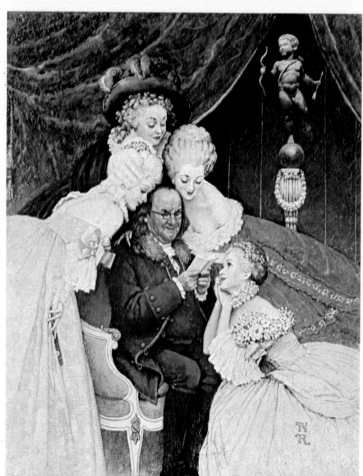

Ben Franklin's Belles.
*Original oil painting for illustration
to* Poor Richard's Almanacks, *1963.
Collection Mr. and Mrs. Joseph H. Hennage*

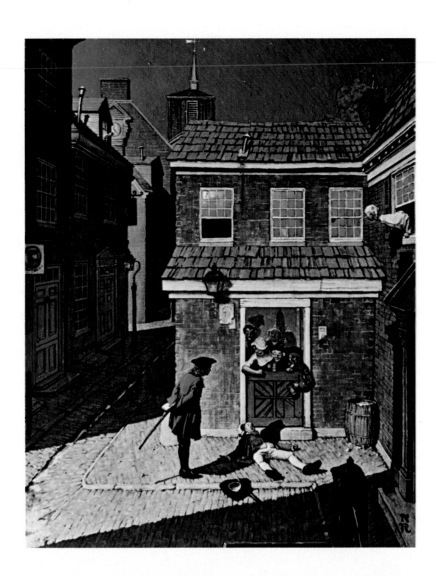

The Tavern.
*Original oil painting for illustration
to* Poor Richard's Almanacks, *1963.
Collection Mr. and Mrs. Joseph H. Hennage*

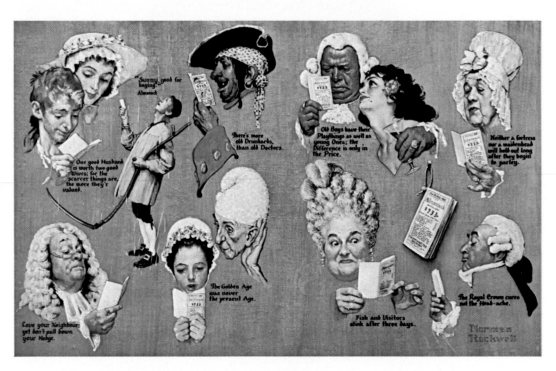

Almanac Scenes. *Original oil painting for illustration to* Poor Richard's Almanacks, *1963.
Collection Mr. and Mrs. Joseph H. Hennage*

Rockwell and Goldwater.
Charcoal drawing for Look, *October 20, 1964.*
Collection Mr. and Mrs. Irving Lehr

Norman Rockwell at the Barber.
Charcoal drawing for Look, *October 20, 1964.*
Collection Mr. and Mrs. William R. Meyers

Barry Goldwater.
Sketch for Look, *October 20, 1962.*
Private collection

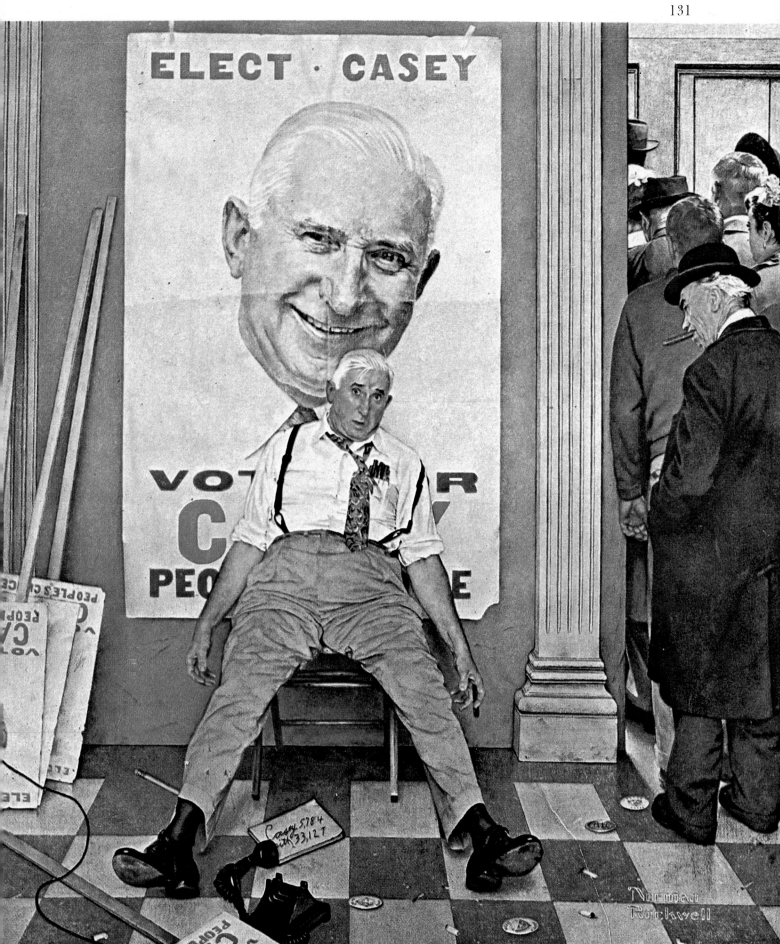

Elect Casey. *Original oil painting for* Post *cover, November 8, 1958. Collection* Saturday Evening Post

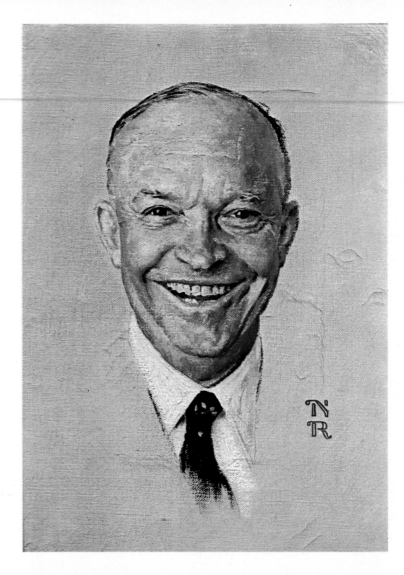

Portrait of Eisenhower.
1952. Original oil painting.
Collection Mr. and Mrs. Ken Stuart

Portrait of Nixon.
Original oil painting
for Post *cover, November 5, 1960.*
Collection University Computing Company,
Dallas, Texas

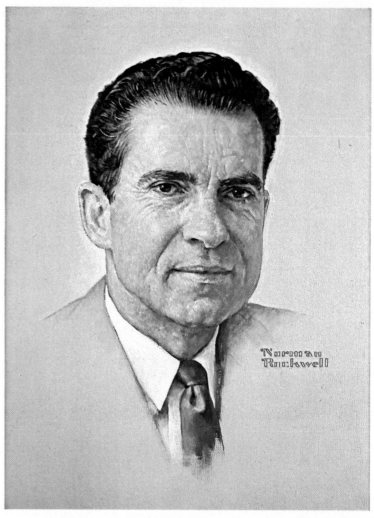

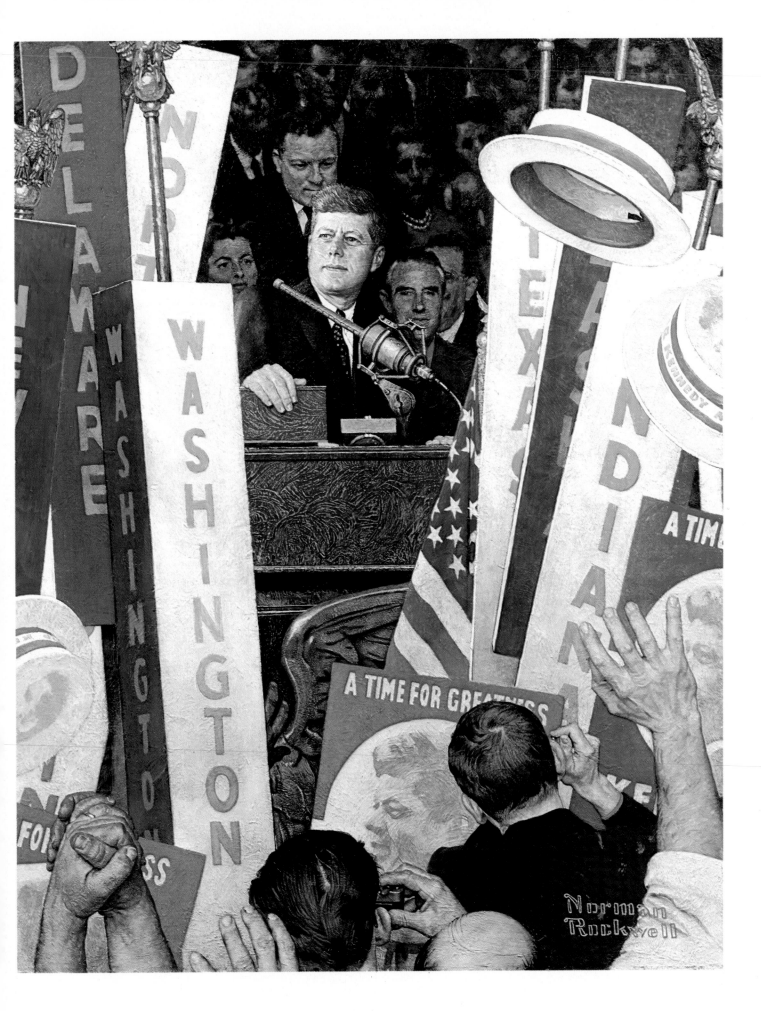

A Time for Greatness. *Original oil painting for* Look *cover, July 14, 1964. Collection Harry N. Abrams, Inc., New York*

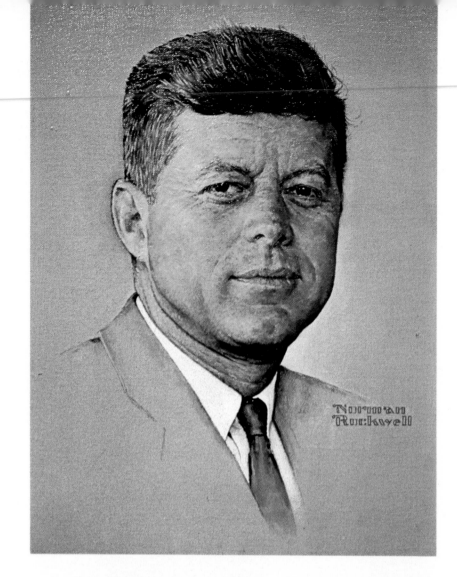

Portrait of Kennedy.
Original oil painting for Post *cover,*
October 29, 1960.
Private collection

JFK's Bold Legacy—Peace Corps.
Oil sketch for Look *cover,*
June 14, 1966.
Collection Mr. and Mrs. Jerome D. Mack

tographs of each individual, the series is characterized by painstaking rendering with emphasis on the unifying effect of common, usually strong, light sources.

In his final year at the *Post*, 1963, all of the covers were portraits. The art editor had approved a group of storytelling ideas, but as the editor did not use them they went with Rockwell when he left.

The assigned subjects Rockwell now accepts are big and important and challenging. Rockwell meets them with enthusiasm and imagination. But he has not changed. He still paints Christmas and funny-sad stories and springtime. He still likes his edges well-defined and, in spite of outer space, he likes his backgrounds close in and parallel to the picture plane. Horizontals and verticals make him

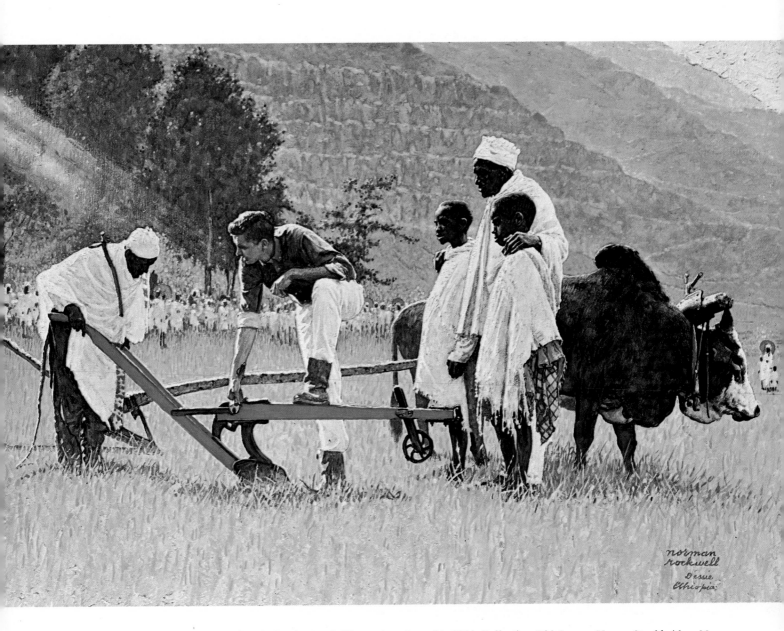

The Peace Corps in Ethiopia. *Original oil painting for* Look *illustration, June 14, 1966. Collection Old Corner House, Stockbridge, Mass.*

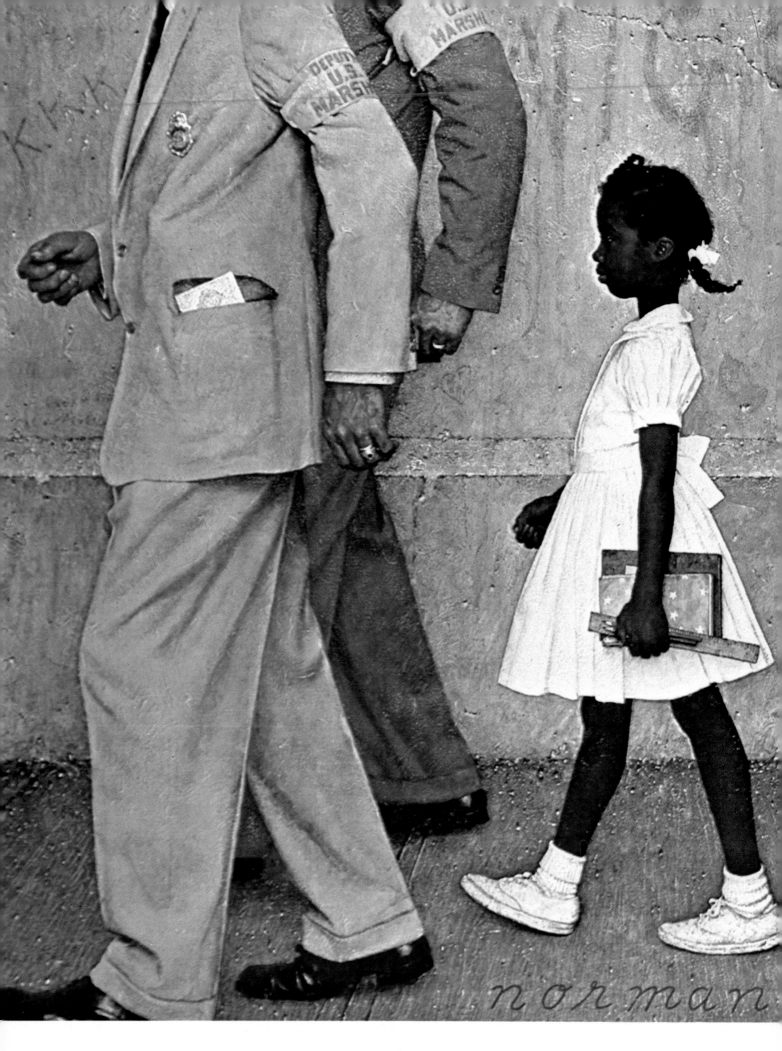

THE PROBLEM WE ALL LIVE WITH

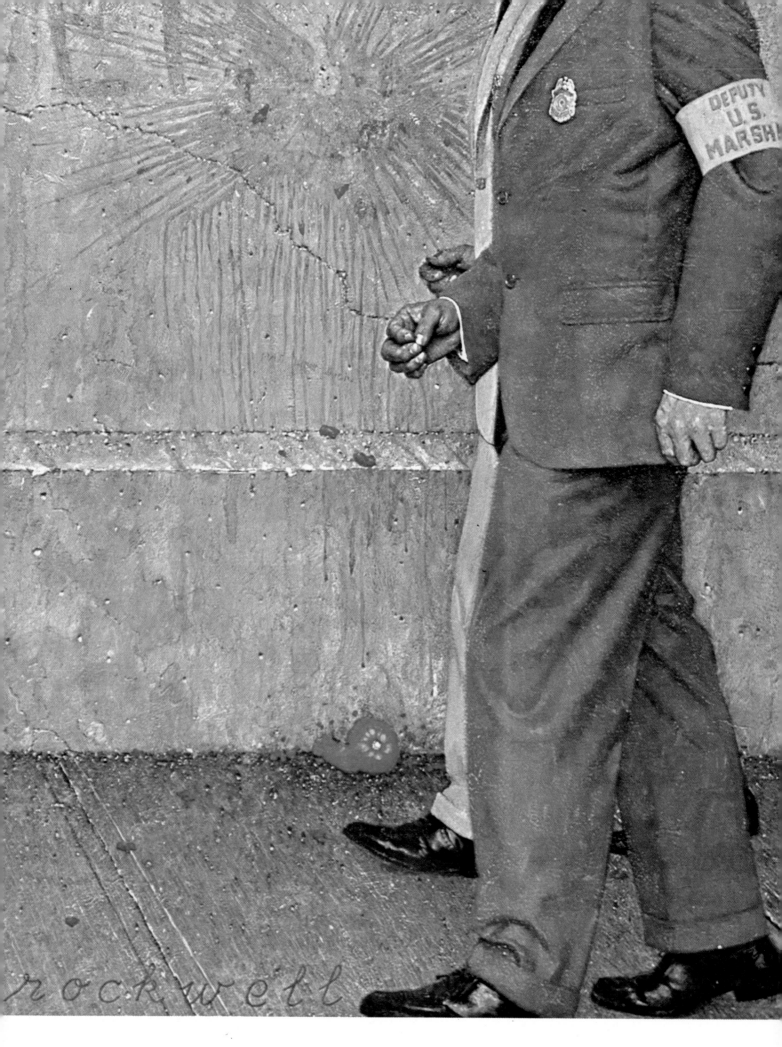

Original oil painting for Look, *January 14, 1964. Collection Jack Solomon*

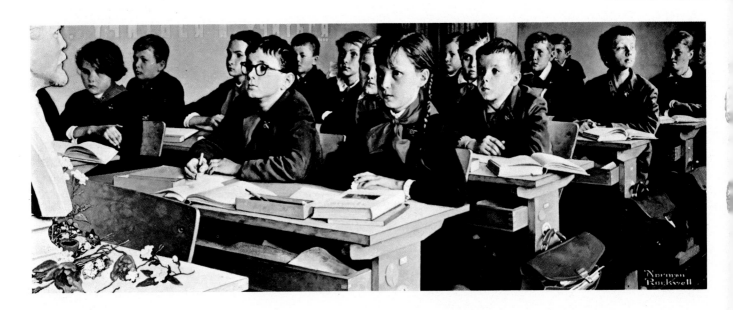

Russian Classroom. *Original oil painting for* Look *illustration, October 3, 1967. Collection Jack Solomon*

Bertrand Russell.
Original oil painting for Ramparts
illustration, May, 1967.
Collection Norman Rockwell

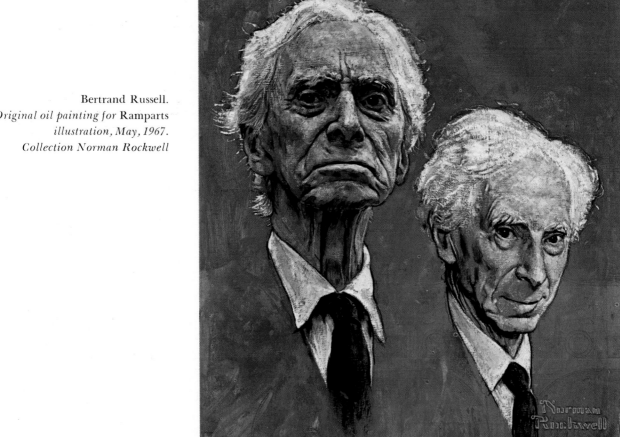

Detail of
Advertisement for Massachusetts Mutual
Life Insurance Company

◀ M O V I N G I N

Original oil painting for Look *illustration, May 16, 1967.*
Collection Old Corner House, Stockbridge, Mass.

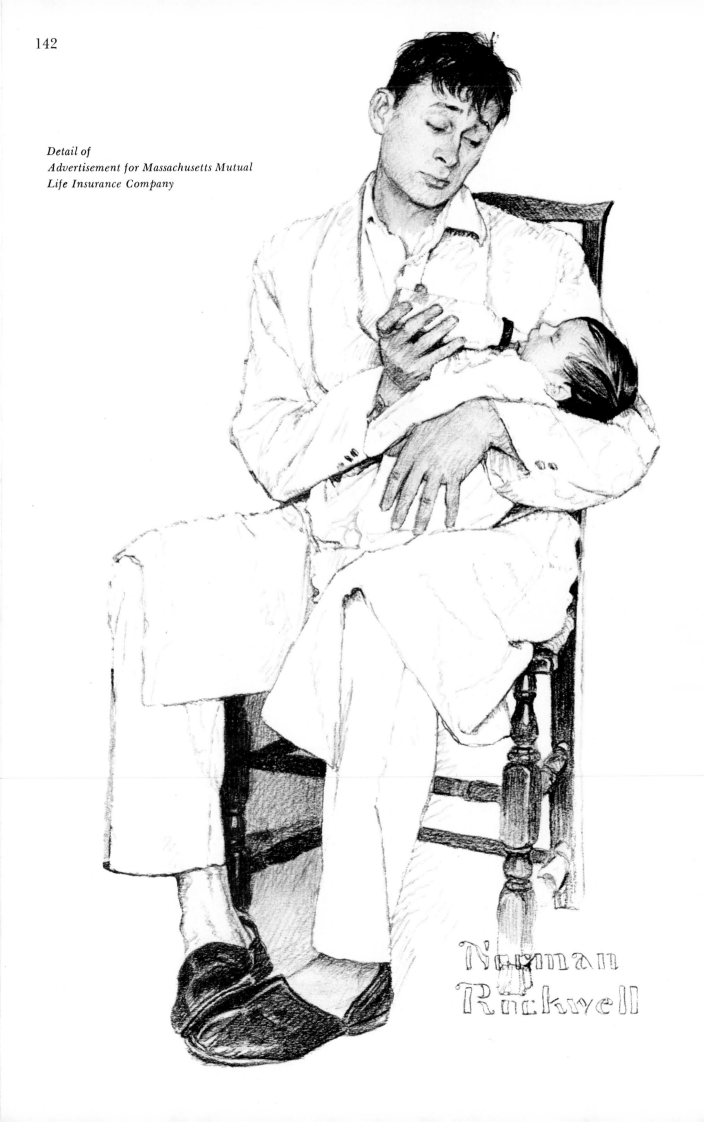

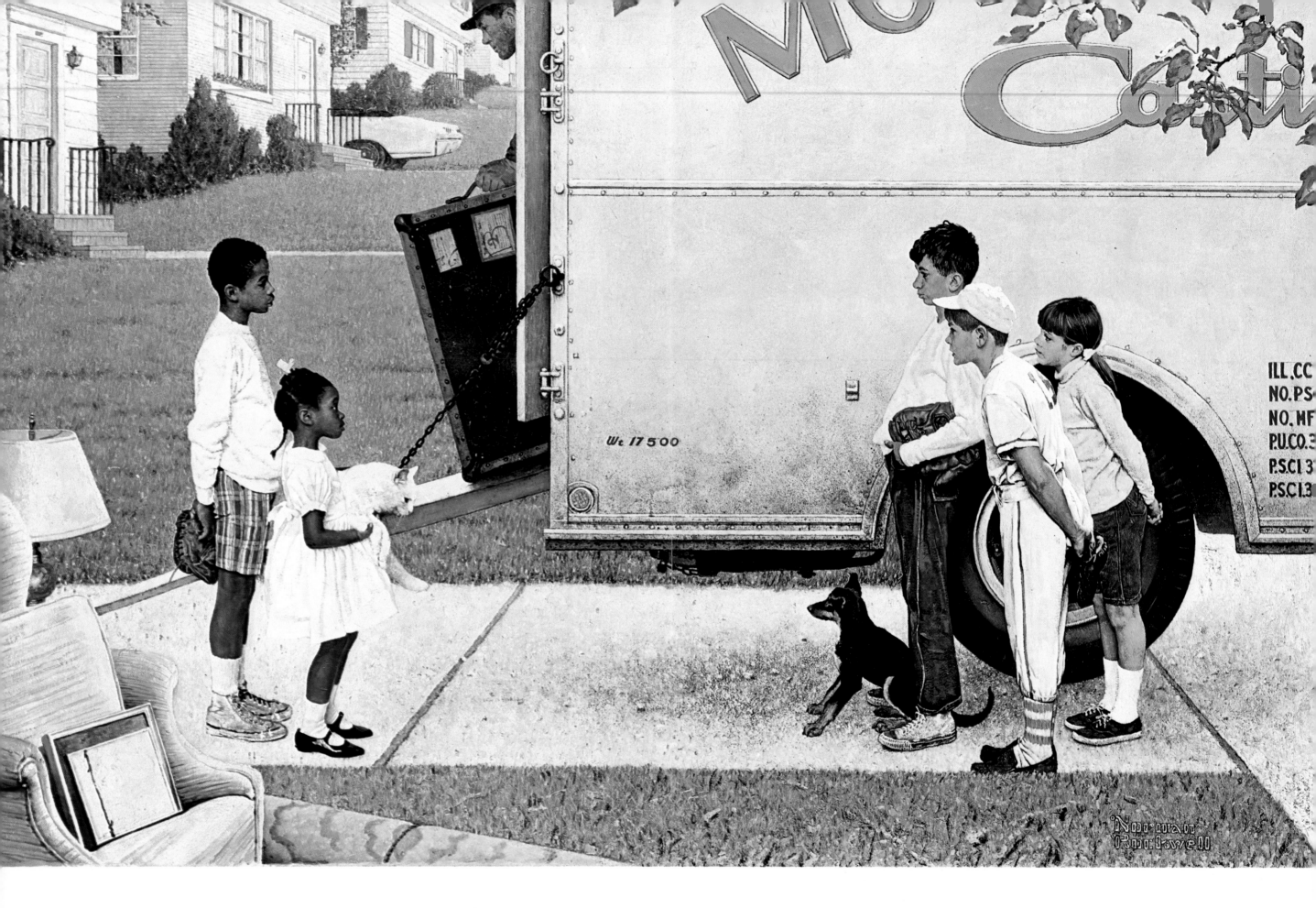

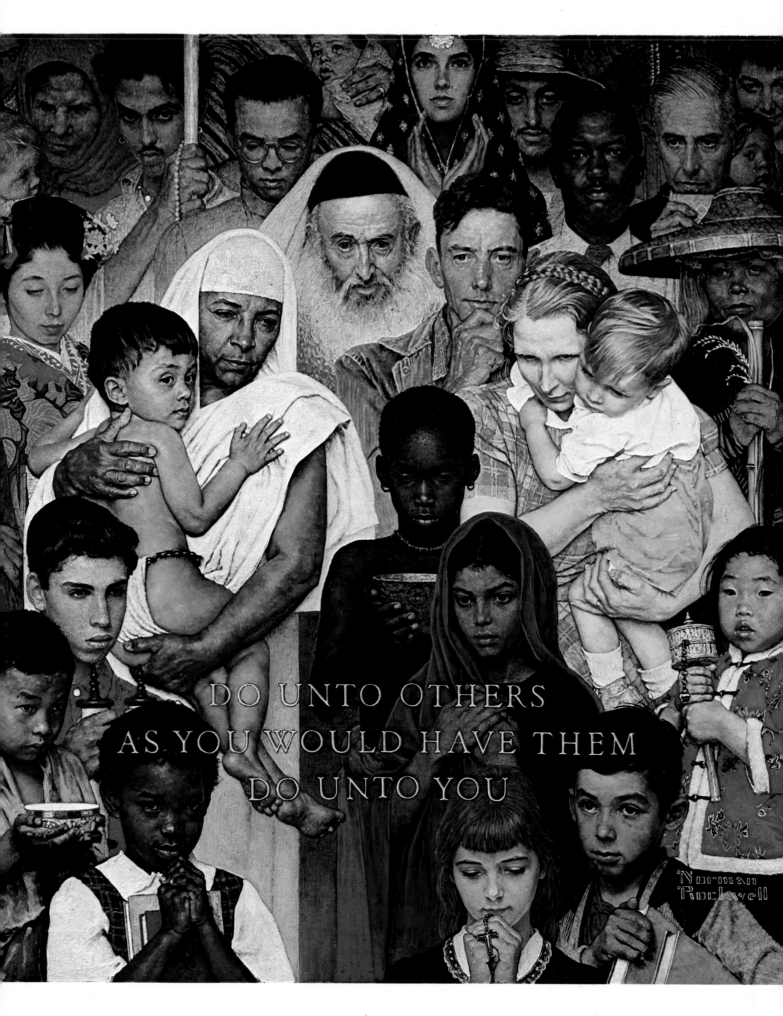

DO UNTO OTHERS
AS YOU WOULD HAVE THEM
DO UNTO YOU

The Golden Rule. *Original oil painting for* Post *cover, April 1, 1961. Collection Norman Rockwell*

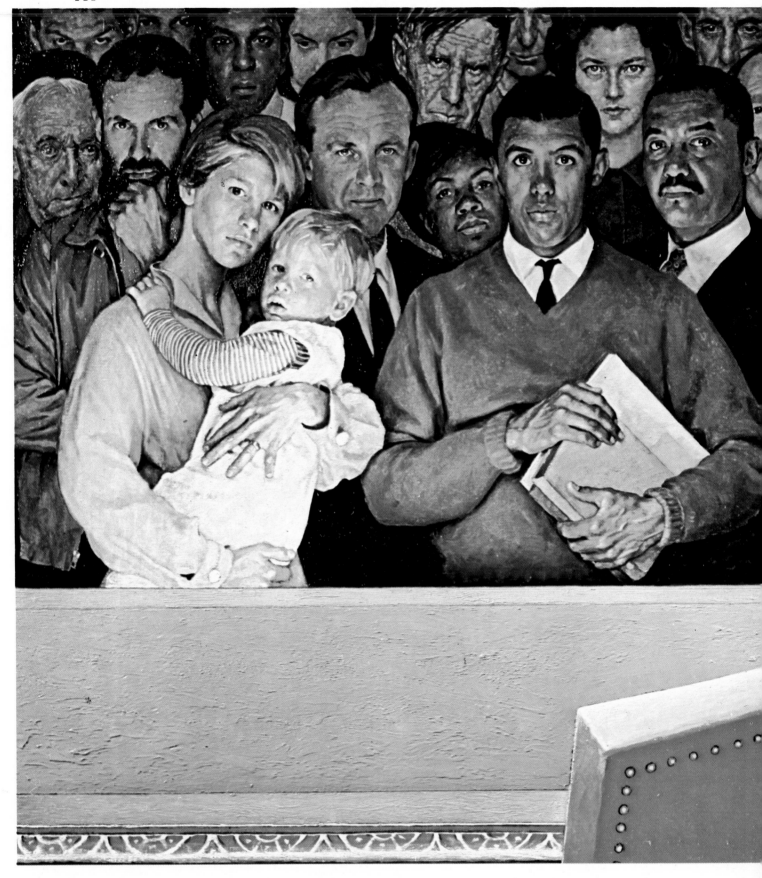

THE RIGHT TO KNOW

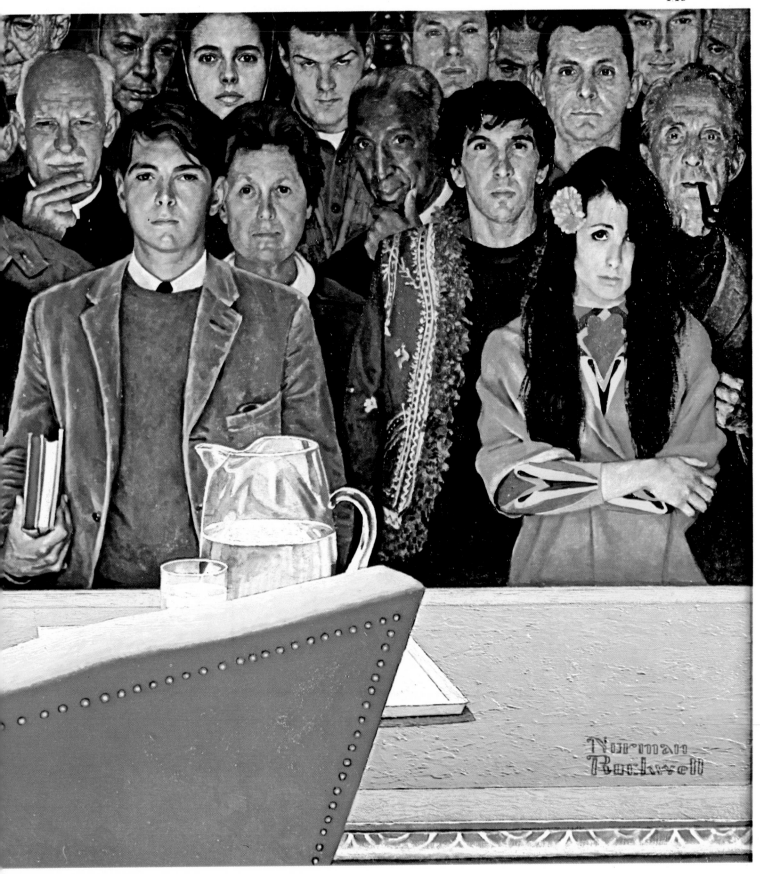

Original oil painting for Look *illustration, August 20, 1968. Collection Irving Mitchell Felt*

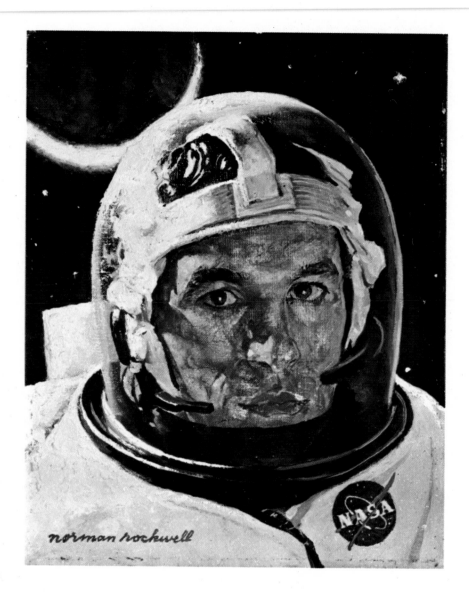

Portrait of an Astronaut.
Original oil painting for Look,
January 10, 1967.
Collection Aerospace Museum,
Smithsonian Institution,
Washington, D.C.

happier than diagonals, and the object in the foreground still invites us into the picture. Facial expressions are more serious, and the people who wear them are more important, but they still bring things to life as only Rockwell can. He has not abandoned average America, but he has become increasingly specific. His portrait of the nation may be one-sided but it is up-to-date—and, as always, more benevolent than deserved.

Man's First Step on the Moon. *Original oil painting for* Look *illustration, January 10, 1967.* ▶
Collection Aerospace Museum, Smithsonian Institution, Washington, D.C.

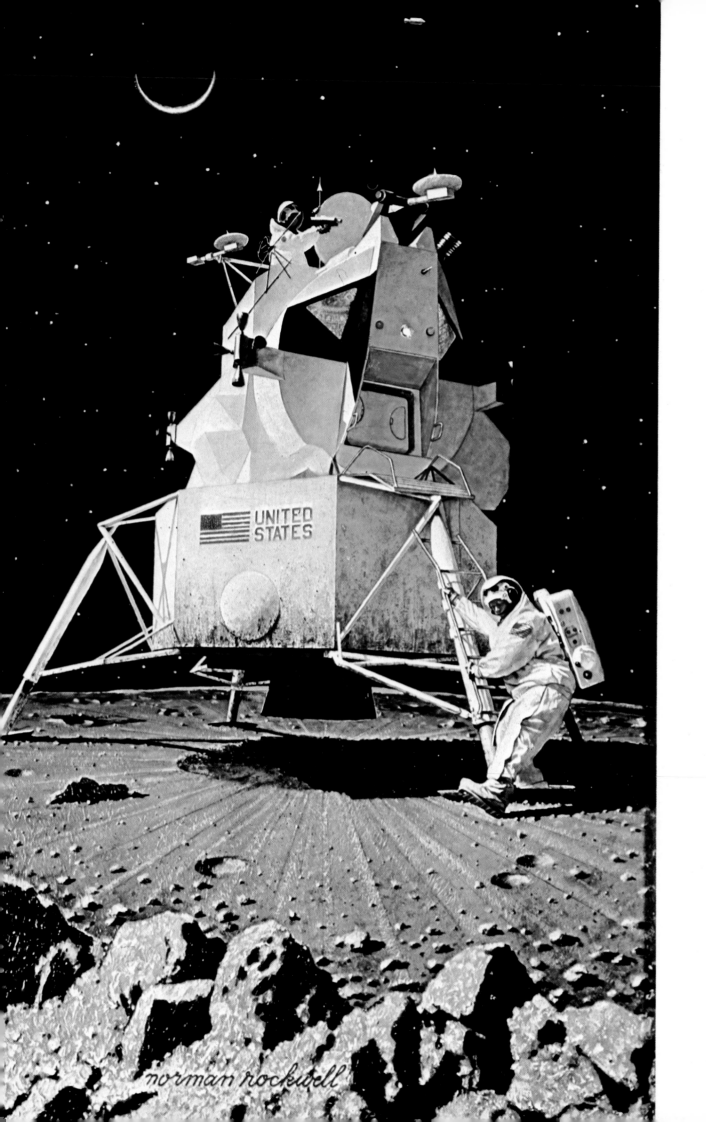

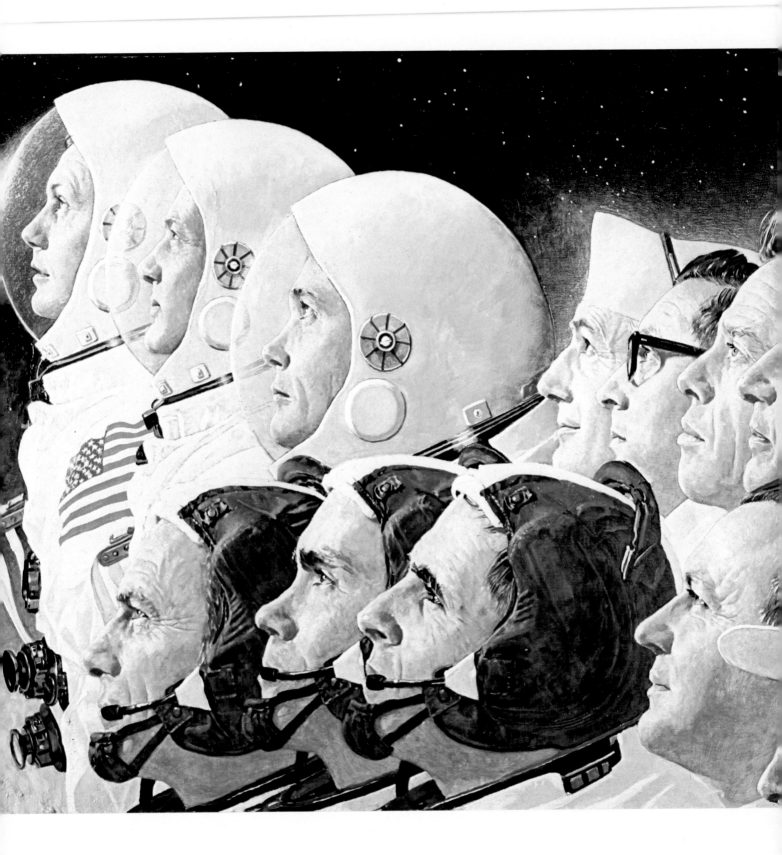

APOLLO 11 SPACE TEAM

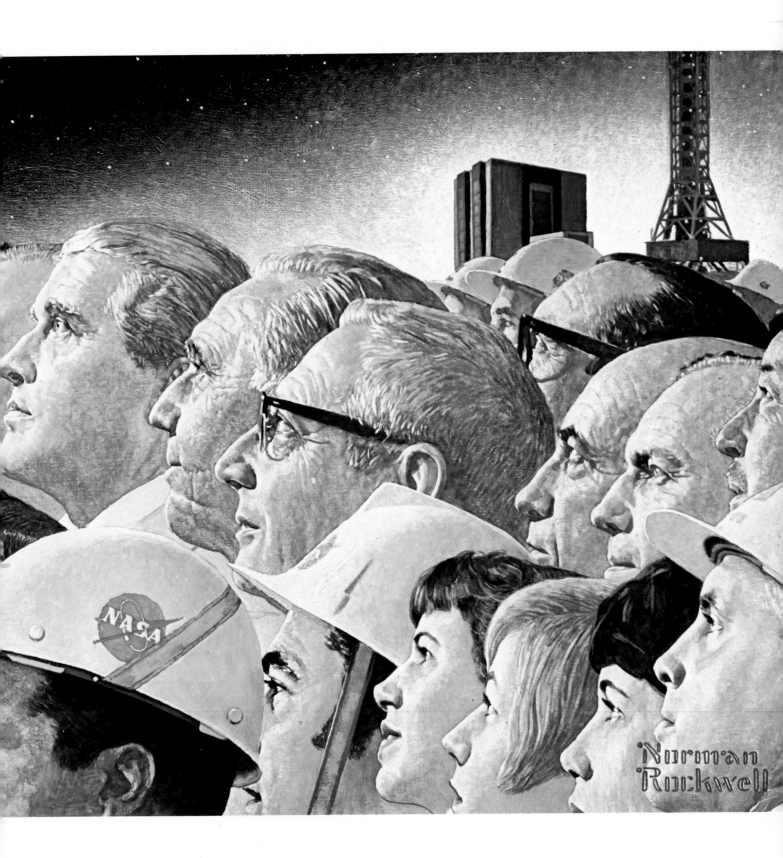

Original oil painting for Look *illustration, July 15, 1969. Collection Aerospace Museum, Smithsonian Institution, Washington, D.C.*

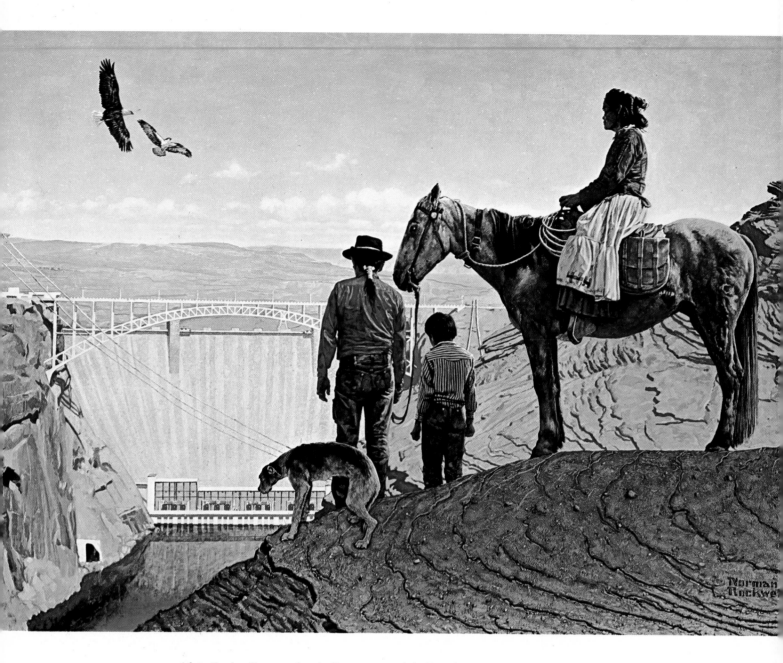

A late Rockwell canvas for the Department of the Interior, Bureau of Reclamation. 1970

LIST OF PLATES

*asterisks * indicate colorplates*